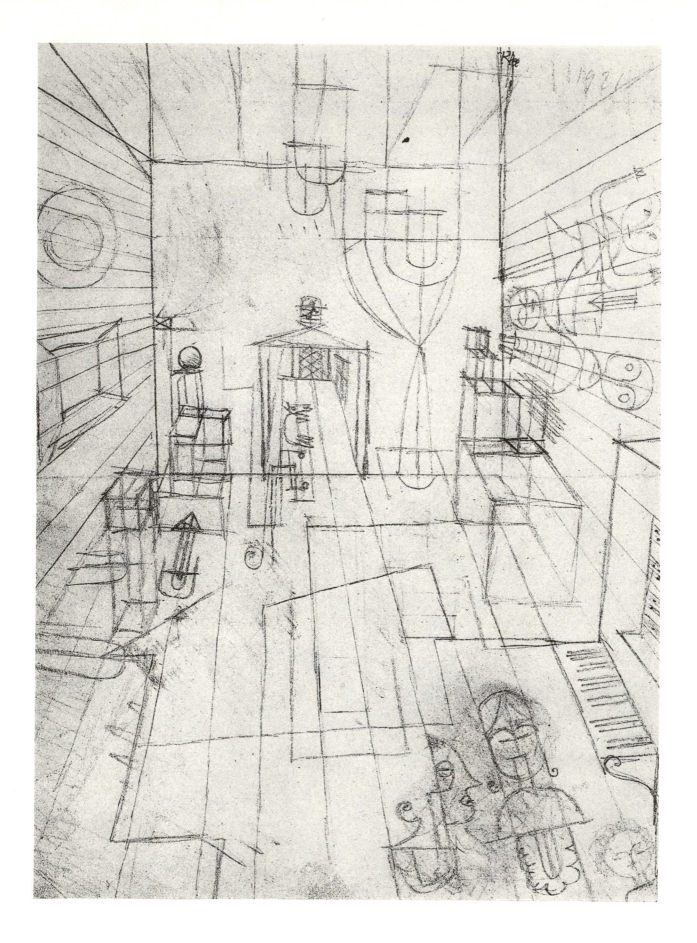

Study for "Perspective of a Room with Its Dwellers" (Zur "Zimmerperspektive mit Ein-wohnern"). 1921. Pencil. 13⅜ x 9⅞ inches.

KLEE DRAWINGS

60 Works by Paul Klee

DOVER PUBLICATIONS, INC.
NEW YORK

PUBLISHER'S NOTE

The Swiss-German artist Paul Klee (1879–1940) is perhaps even more famous for his watercolors and oils than for his black-and-white drawings, but it is the latter aspect of his production that shows most clearly the fundamental primacy in his art of line, or to be more precise: line in movement.

Of Klee's thousands of drawings, some of course were preparations for larger works in color, but many others were completely independent explorations of themes and concepts. About 1200 black-and-white drawings were created in the ten-year period, 1921–1930, covered in the present volume, a period practically coextensive with Klee's activity as a teacher at the celebrated Bauhaus, located first in Weimar, then in Dessau, Germany.

The rich selection offered here, done in a wide variety of media, is typical of Klee's work, with its fresh and imaginative reordering of visual elements (strongly influenced by the art of children and of non-European peoples); its obsession with pattern and structure, deeply tinged with the artist's feeling for the underlying structures of music; and its reliance on personal hieroglyphs and symbols, whether traditional (such as arrows and punctuation marks) or invented.

These symbols may form building blocks in a never-openly-stated story line, or they may stand for various emotional states or even represent formal concepts (such as investigations of space/time relationships). But despite its cerebral nature, Klee's art has always been popular because it never completely loses touch with a recognizable reality, and because it is imbued with a genial humor that only rarely turns to a more bitter irony.

Copyright © 1982 by Dover Publications, Inc.
All rights reserved under Pan American and International Copyright Conventions.

Published in Canada by General Publishing Company, Ltd., 30 Lesmill Road, Don Mills, Toronto, Ontario.
Published in the United Kingdom by Constable and Company, Ltd.

Klee Drawings, first published by Dover Publications, Inc., in 1982, is a new selection of works.

International Standard Book Number: 0-486-24241-2

Manufactured in the United States of America
Dover Publications, Inc.
180 Varick Street
New York, N.Y. 10014

Library of Congress Cataloging in Publication Data

Klee, Paul, 1879–1940.
 Klee drawings.

 (Dover art library)
 1. Klee, Paul, 1879–1940. I. Title. II. Series. NC251.K54A4 1981
741.9494 81-15111 ISBN 0-486-24241-2 AACR2

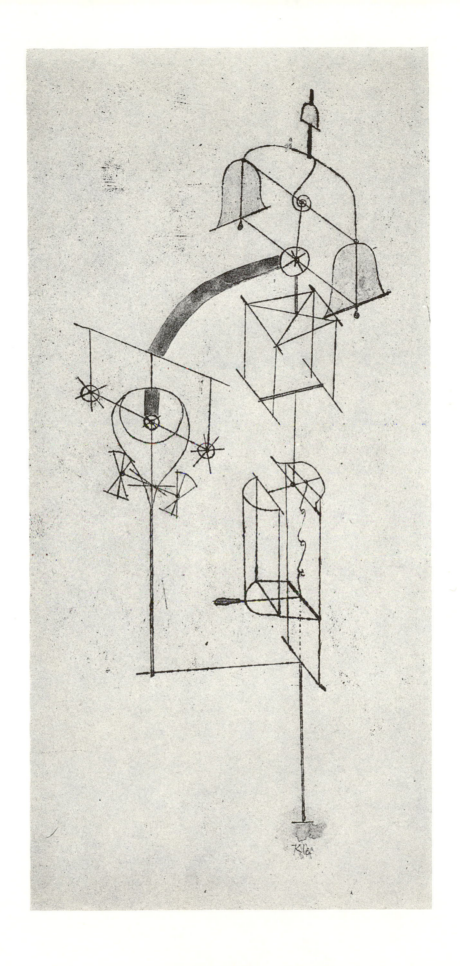

Medical Apparatus from Dr. Ph.'s Office (*Apparat aus dem Ordinationszimmer des Dr. Ph.*). 1922. Crayon. 15⅞ x 7¼ inches.

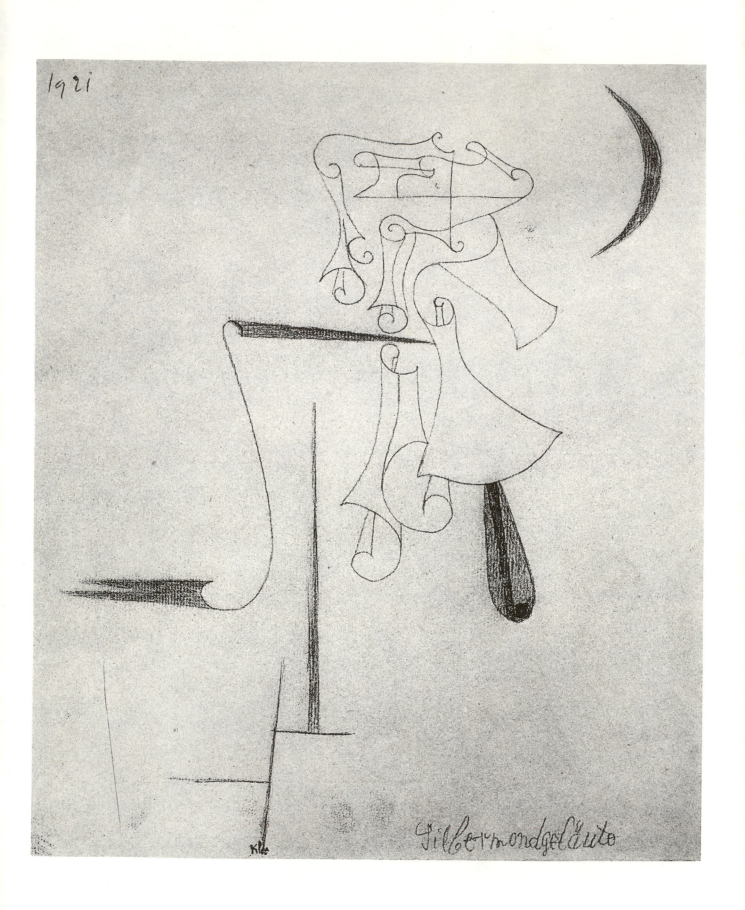

1921

Silbermondgeläute

Pealing of the Silver Moon (*Silbermondgeläute.*) 1921. Pencil. 11¾ x 10⅜ inches.

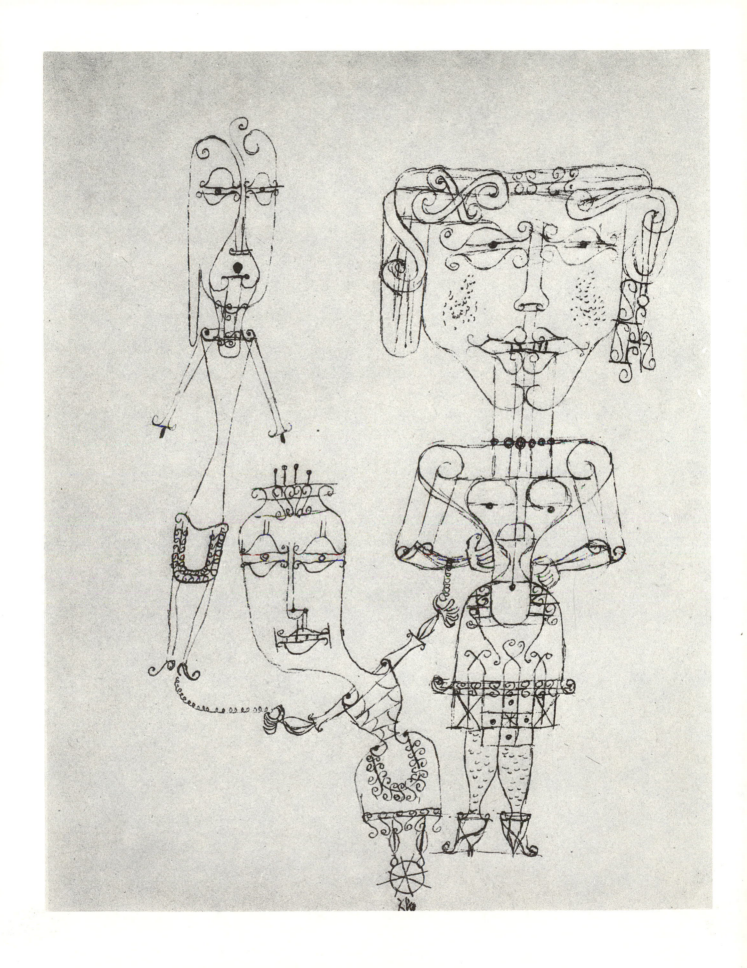

Dressed-up Dolls (*Kostümierte Puppen*). 1922. Pen. 9½ x 6¾ inches.

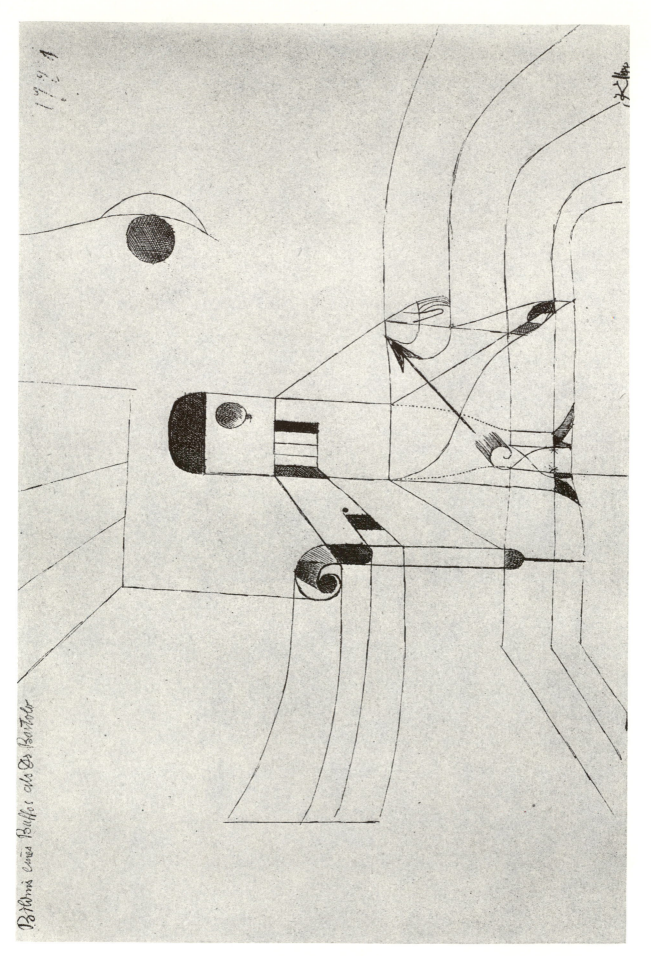

Portrait of a Buffo Bass as Dr. Bartolo [in *The Barber of Seville*] (*Bildnis eines Buffos als Dr. Bartolo*). 1921. Pen. 7⅜ x 11⅛ inches.

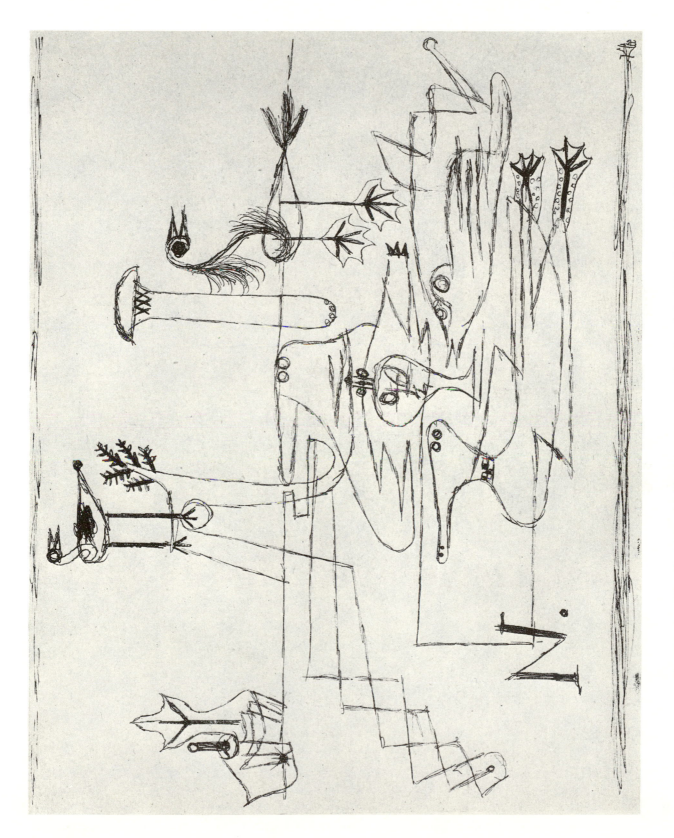

Drawing for "The Bird Islands" (*Zeichnung zu den "Vogelinseln"*). 1921. Pen. 8⅜ x 11¼ inches.

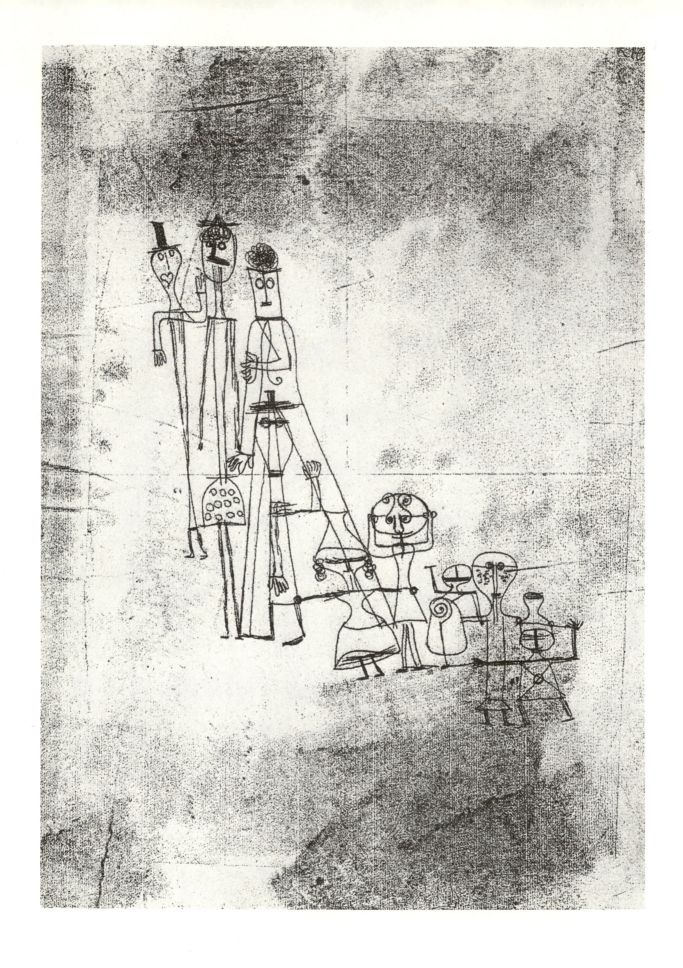

Grown-ups and Kids (*Grosse und Kleine*). 1923. Crayon. 12⅜ x 8⅞ inches.

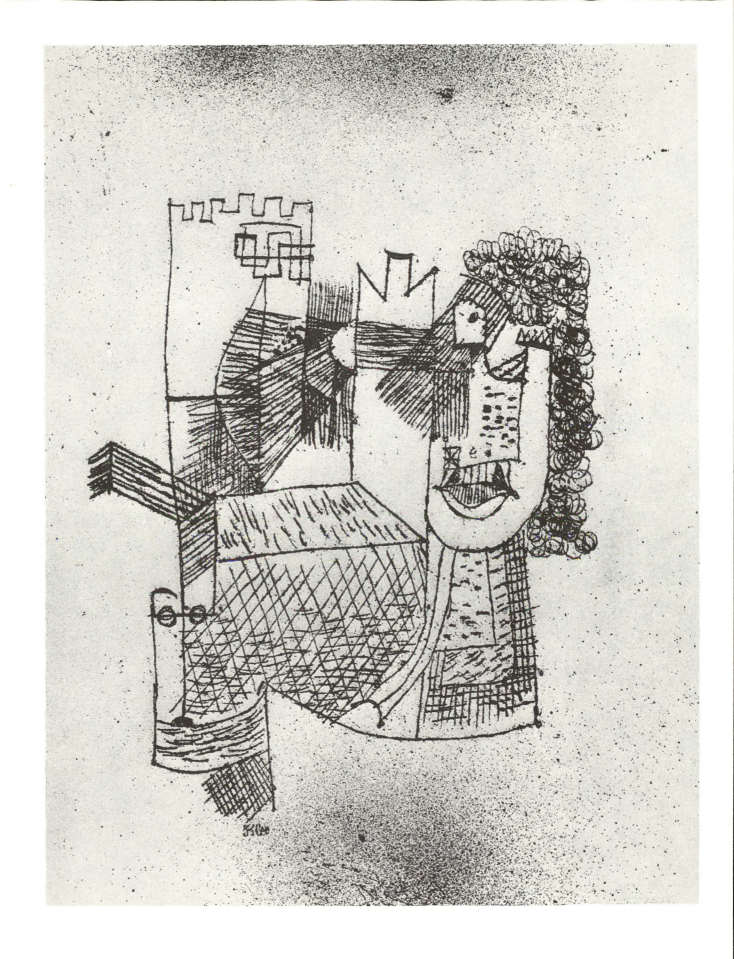

The Solemn Man (*Der Pathetiker*). 1922. Crayon. 9⅛ x 6⅞ inches.

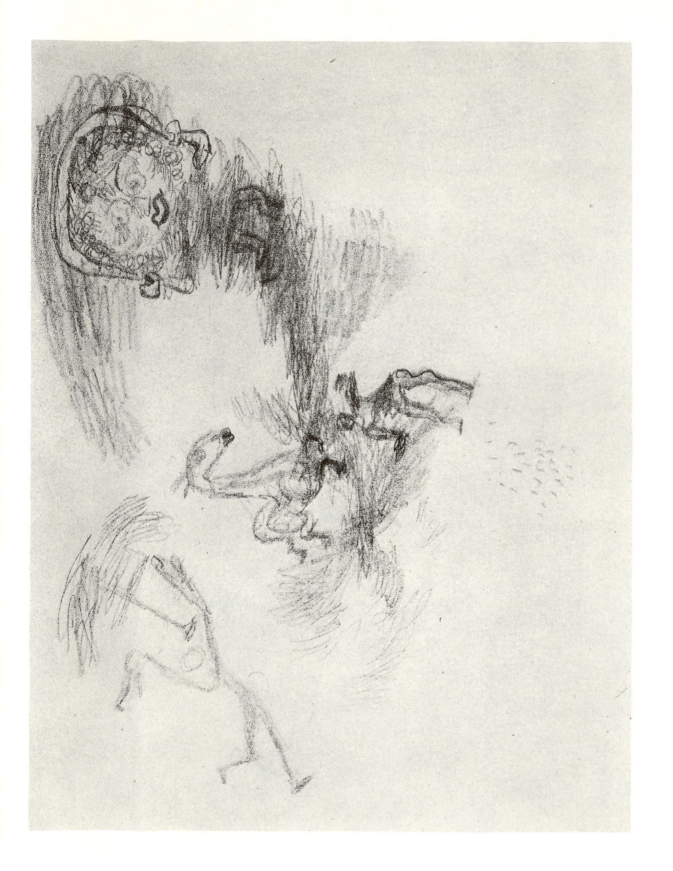

Scene from the Drama of a Riding Master (*Szene aus dem Drama eines Stallmeisters*). 1923. Pencil. 9⅝ x 12 inches.

Trained Wild Horses (*Dressierte Wildpferde*). 1923. Pen. 8⅝ x 11¼ inches.

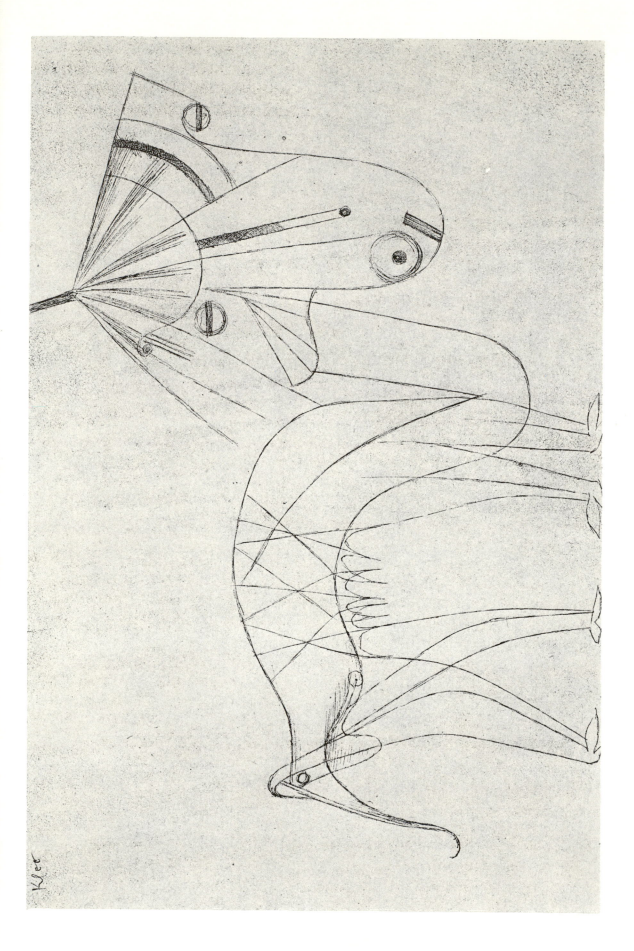

Dwarf Male Camel (*Zwergkamelhengst*). 1922. Pen. 6⅛ x 9⅜ inches.

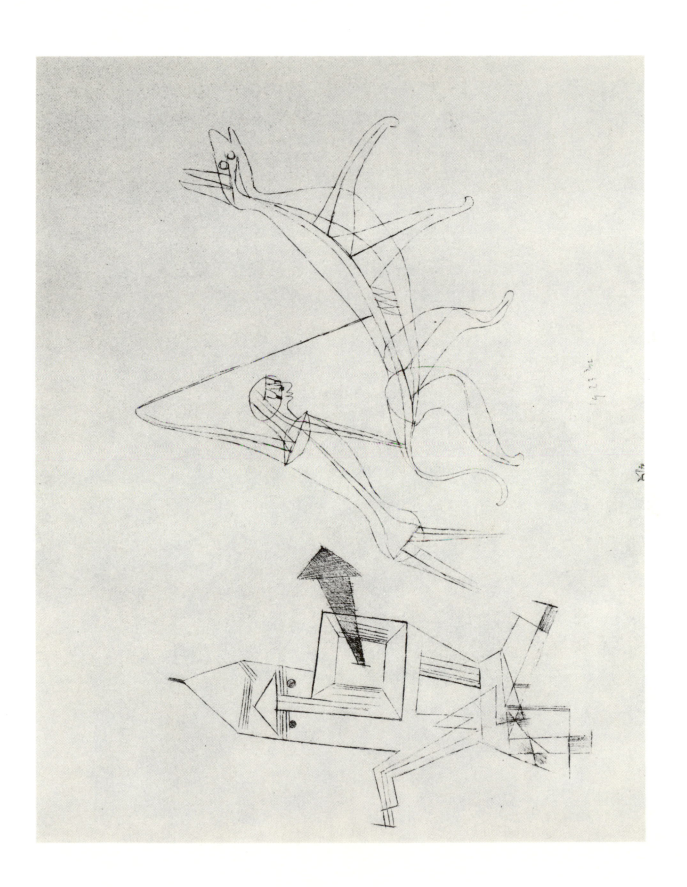

Stylistic (*Stilistisch*). 1923. Pen. 9¾ x 12¾ inches.

11

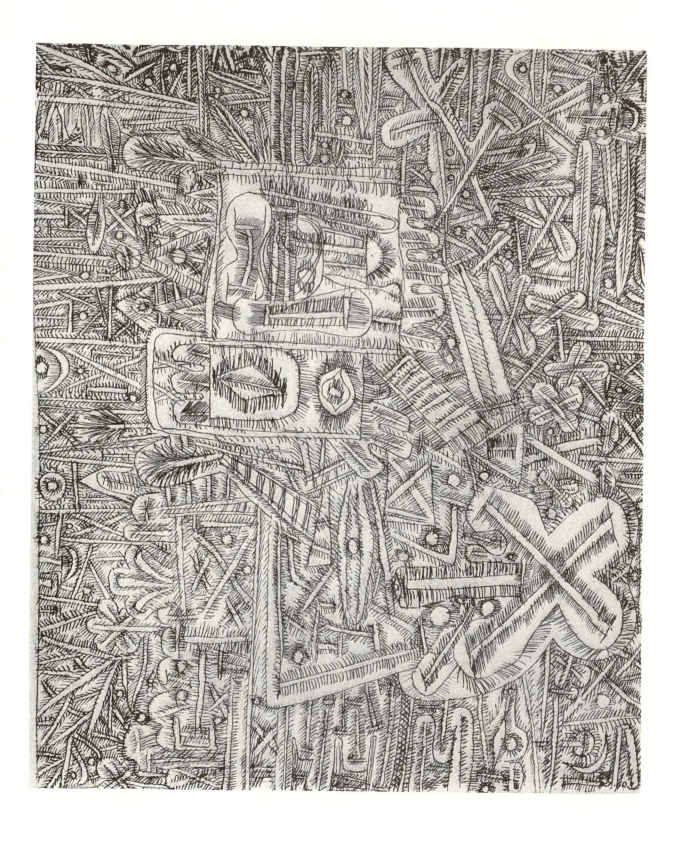

Bazaar Still Life (*Bazarstilleben*). 1924. Pen. 7⅜ x 8⅞ inches.

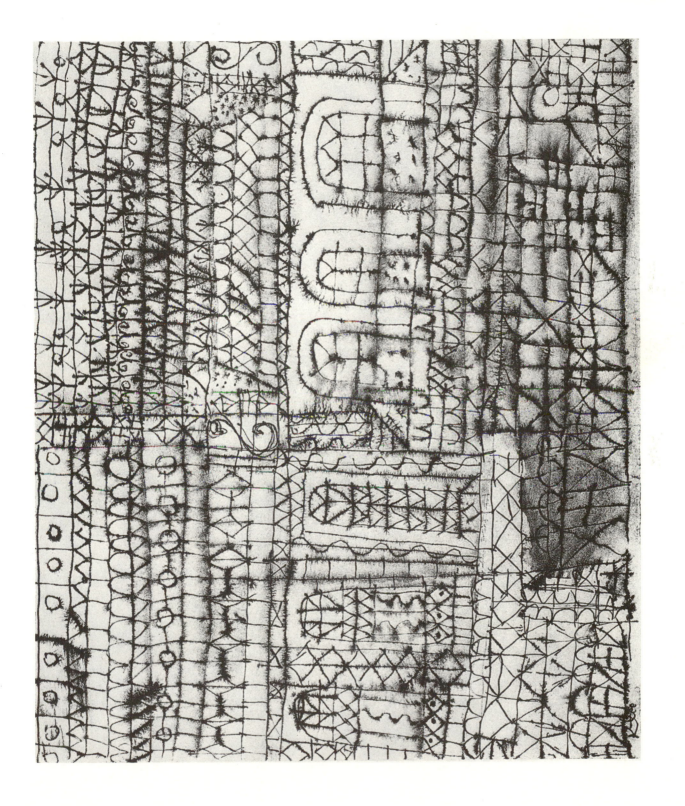

Facade (*Façade*). 1924. Pen. 10¼ x 12⅞ inches.

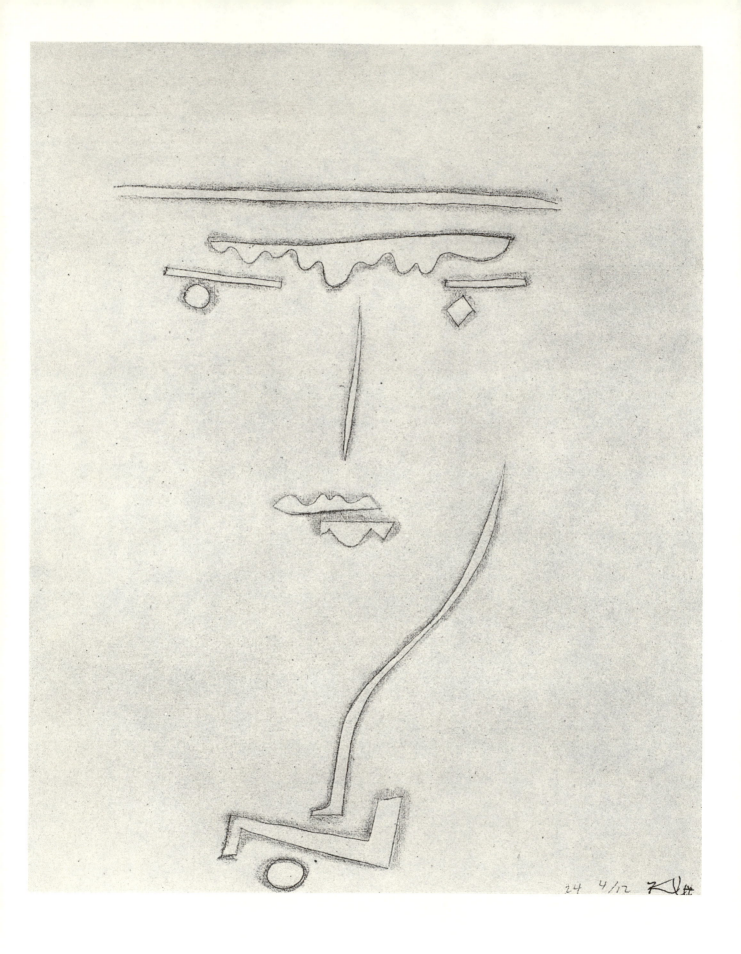

Berta. 1924. Pencil. 11⅛ x 8⅞ inches.

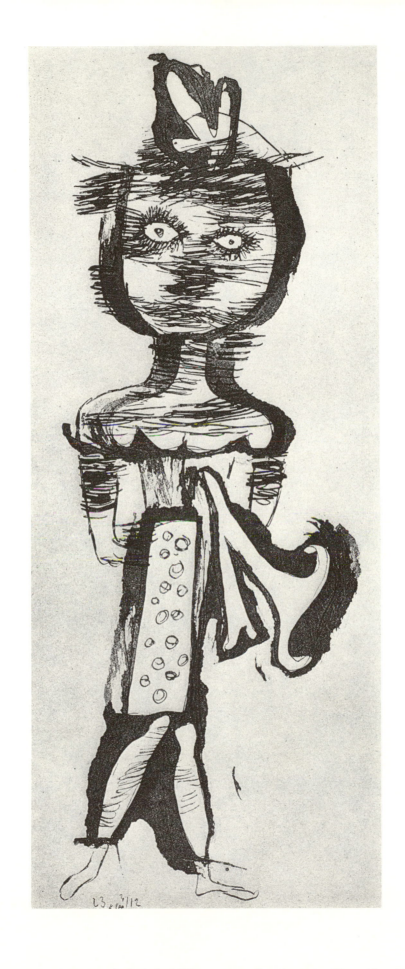

Child's Portrait, Full Length (*Kinderbildnis, ganze Figur*). 1923. Pen. 13 x 5¼ inches.

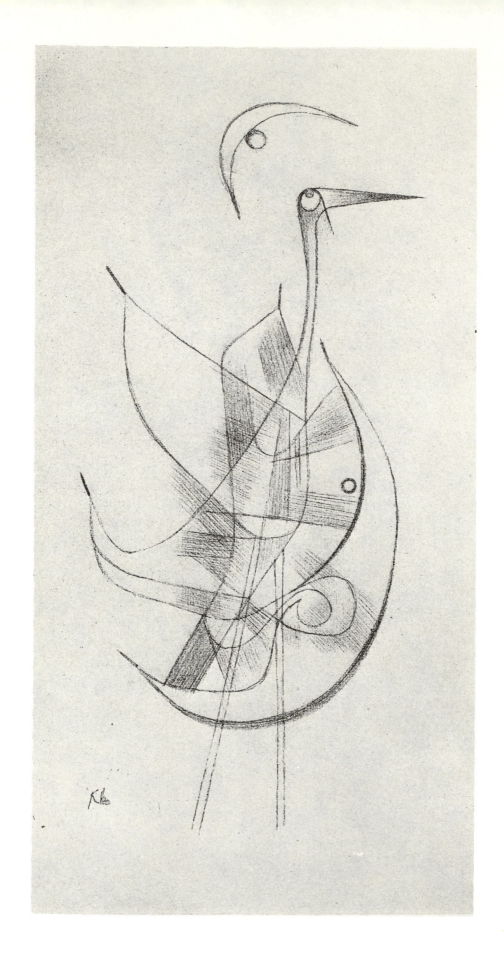

Heron (*Reiher*). 1924. Pencil. 10¼ x 4⅞ inches.

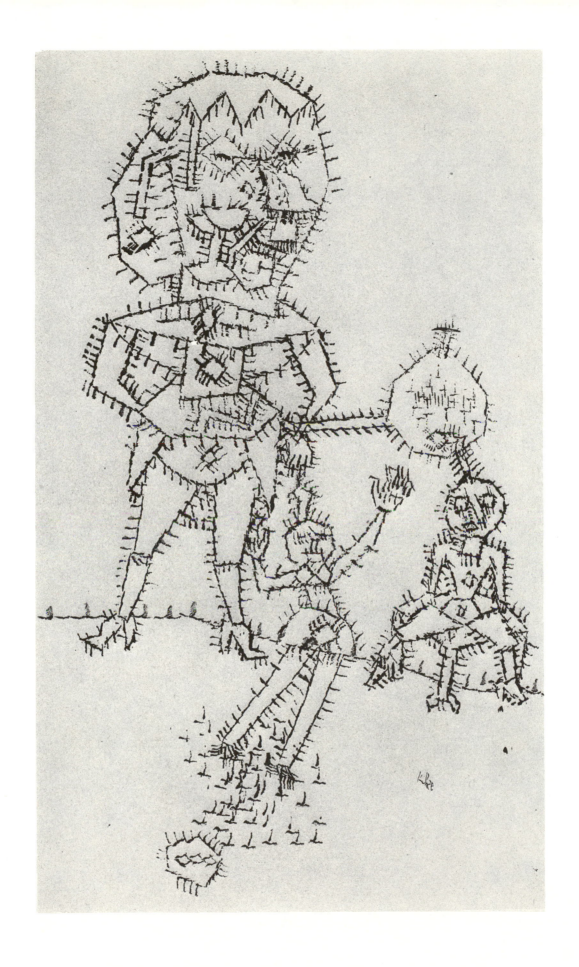

Mother Witch (*Hexenmutter*). 1925. Brush and ink. 9¼ x 5½ inches.

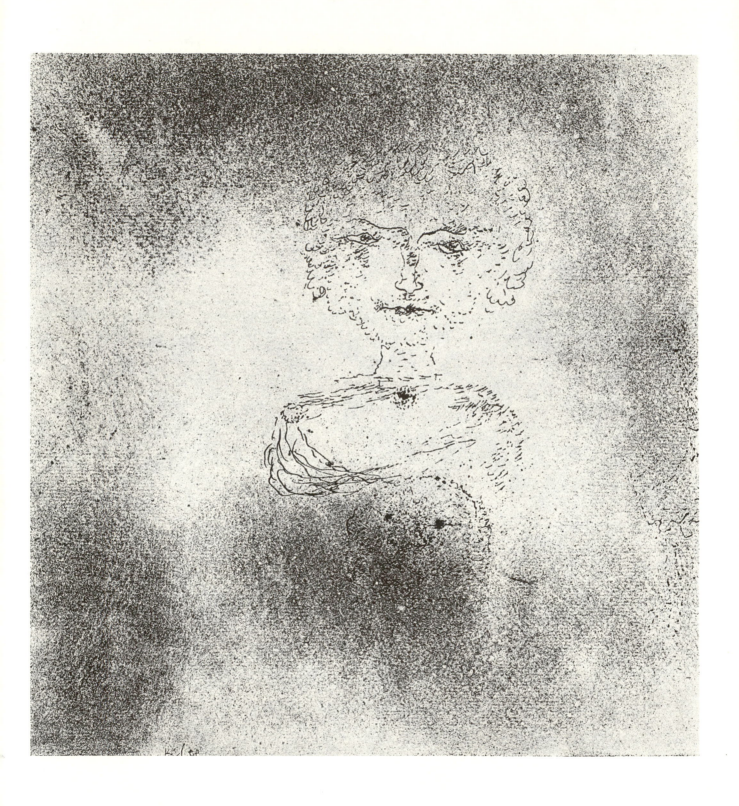

Portrait of a Lady with Her Lapdog (*Bildnis einer Dame mit ihrem Schosshündchen*).
1925. Pen. 9⅛ x 8⅞ inches.

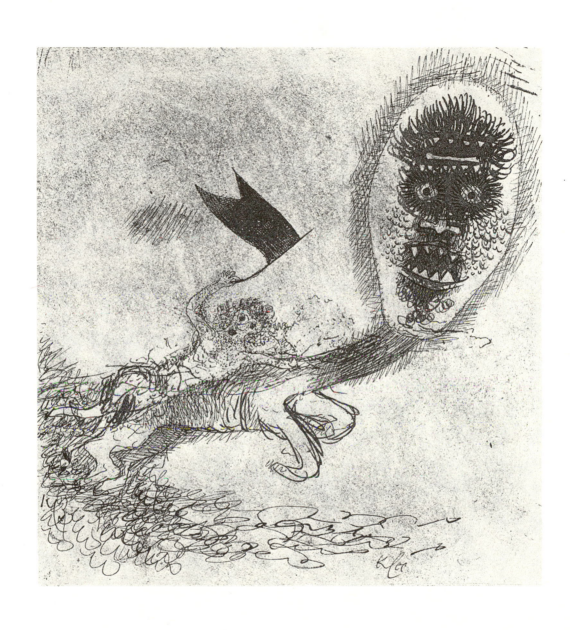

Demonic Ride (*Dämonischer Ritt*). 1925. Pen. 5⅝ x 5¼ inches.

Demonic Scene (*Dämonie*). 1925. Pen. 9⅞ x 21¾ inches.

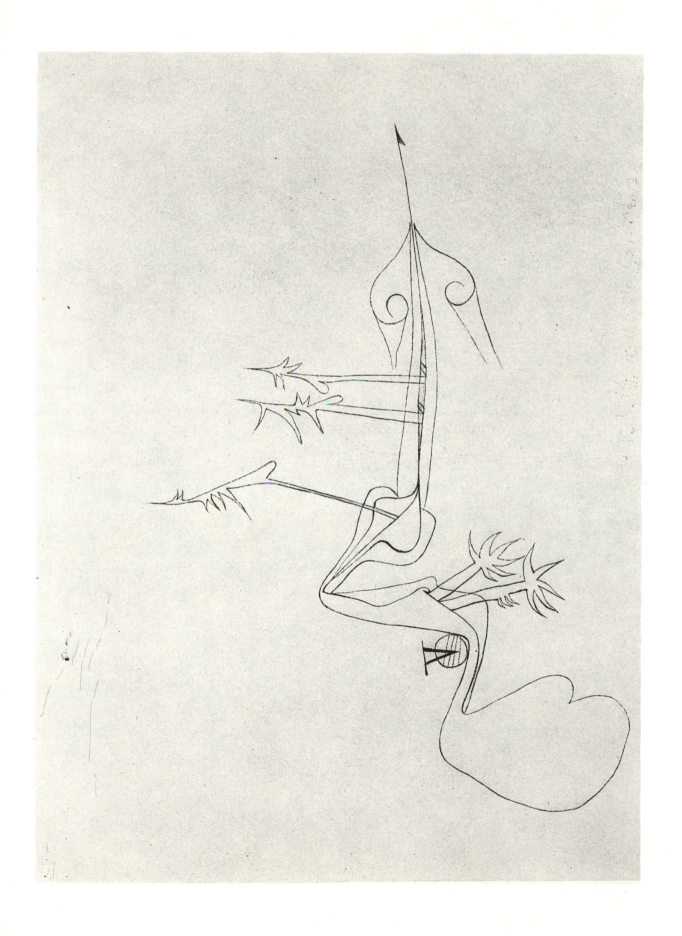

Bewitched Landscape (*Verhexte Landschaft*). 1923. Brush and ink. 10 x 13⅝ inches.

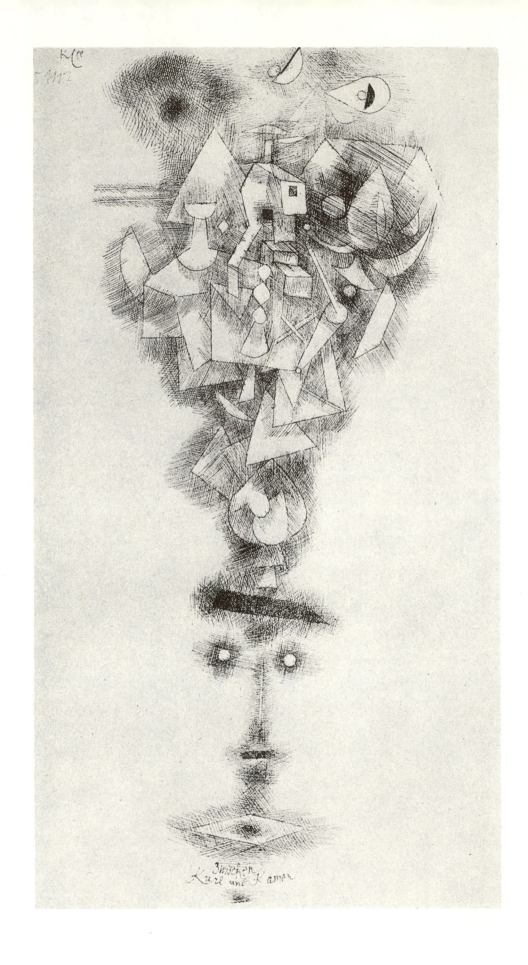

Between Kurl and Kamen [two towns in Germany] (*Zwischen Kurl und Kamen*). 1925.
Pen. 12⅛ x 6⅝ inches.

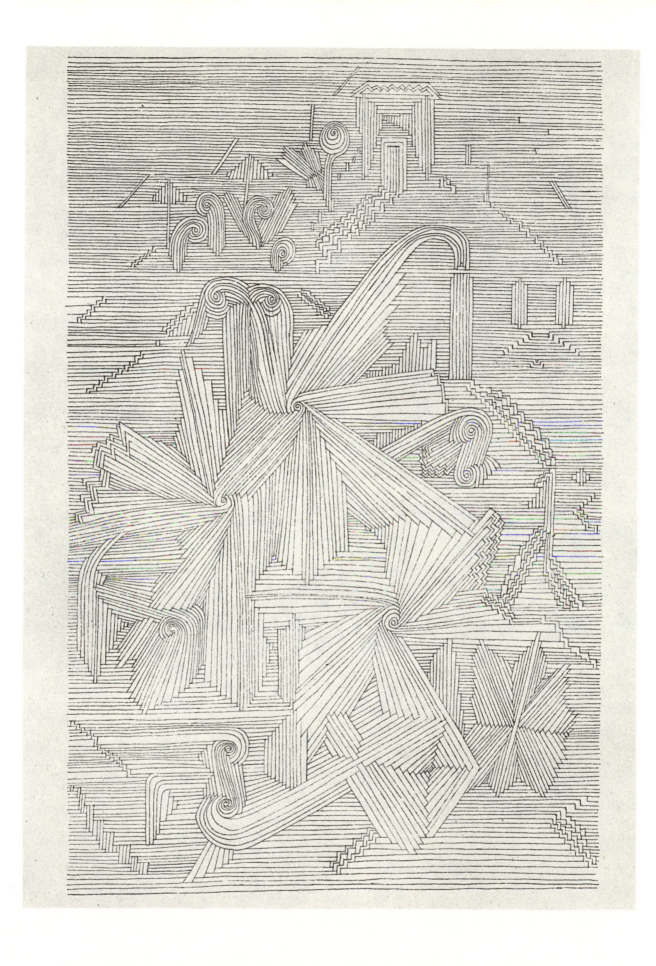

Botanical Garden, Ray-Leaved Plant Division (*Botanischer Garten, Abteilung der Strahlenblattpflanzen*). 1926. Pen. 18⅜ x 12 inches.

Springtime Emotions (*Gefühle im Mai*). 1926. Pen. 5⅝ x 13⅛ inches.

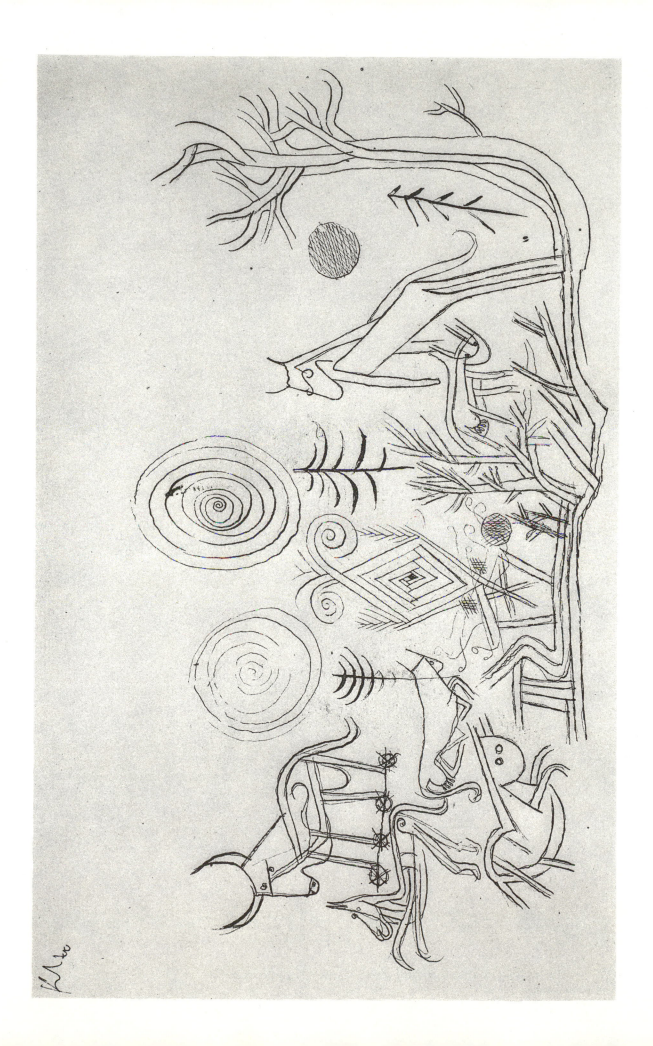

Animal Park (*Tierpark*). 1926. Pen. 7⅜ x 11⅛ inches.

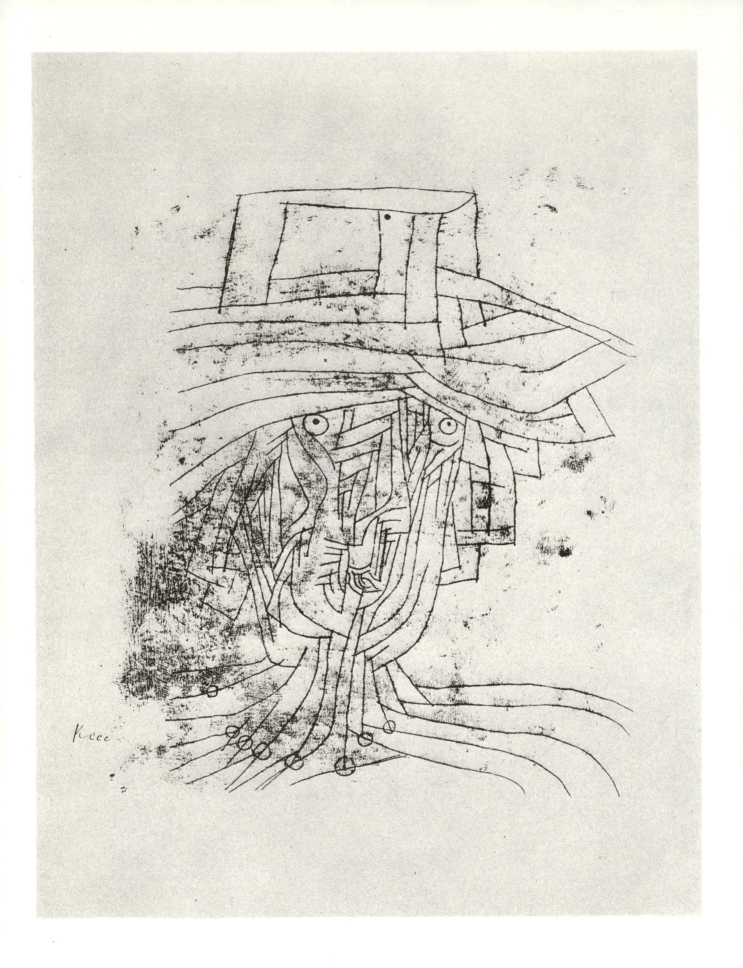

Old Lady (*Alte Dame*). 1926. Crayon. 19⅝ x 15 inches.

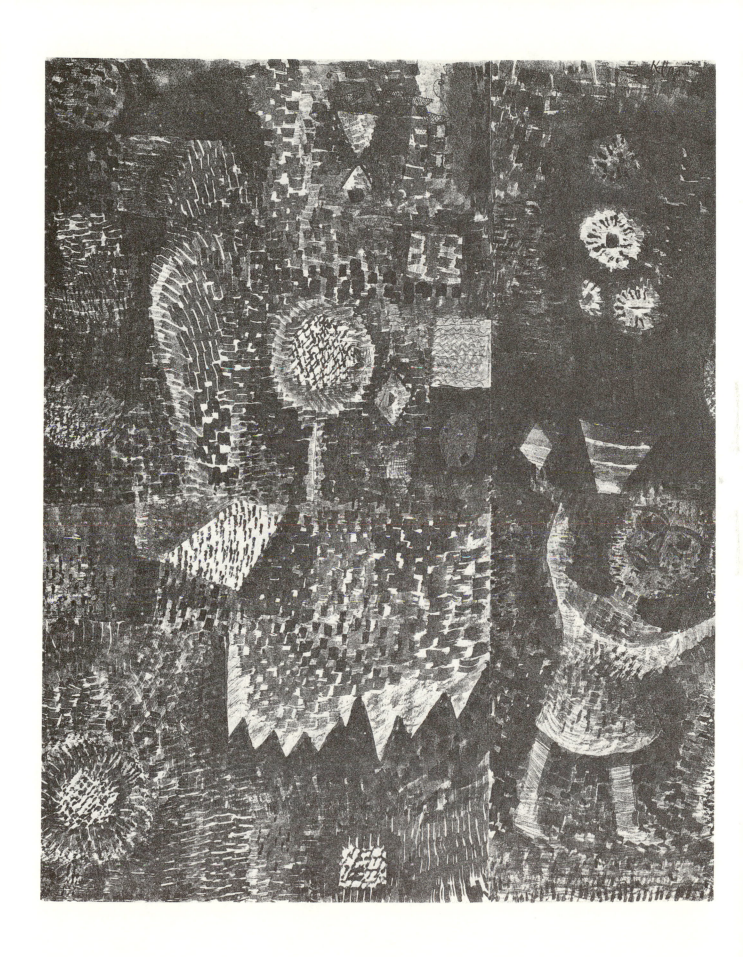

Child in the Aster Garden (*Kind im Asterngarten*). 1925. Brush and ink. 11⅛ x 8⅞ inches.

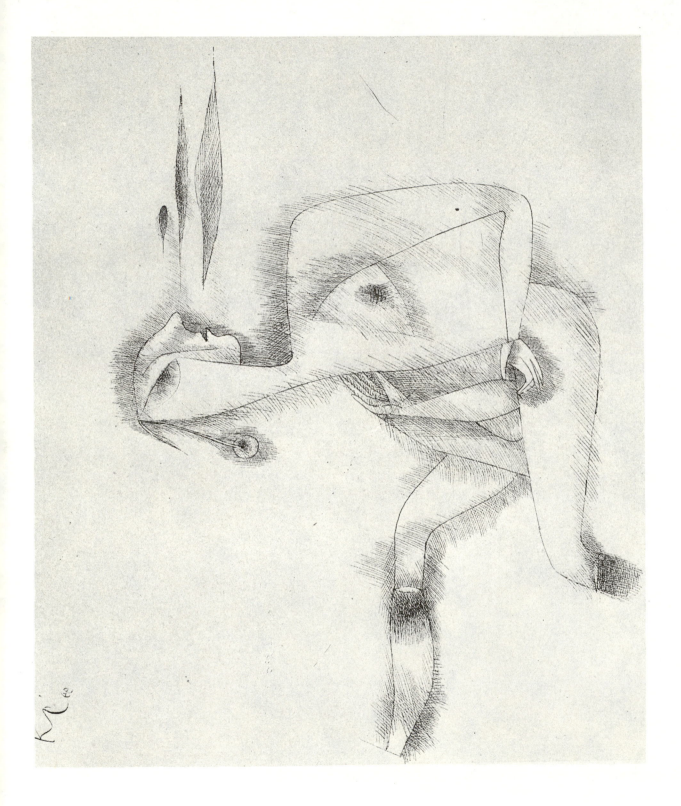

Naked Woman (*Nackte Frau*). 1926. Pen. 10⅛ x 11¾ inches.

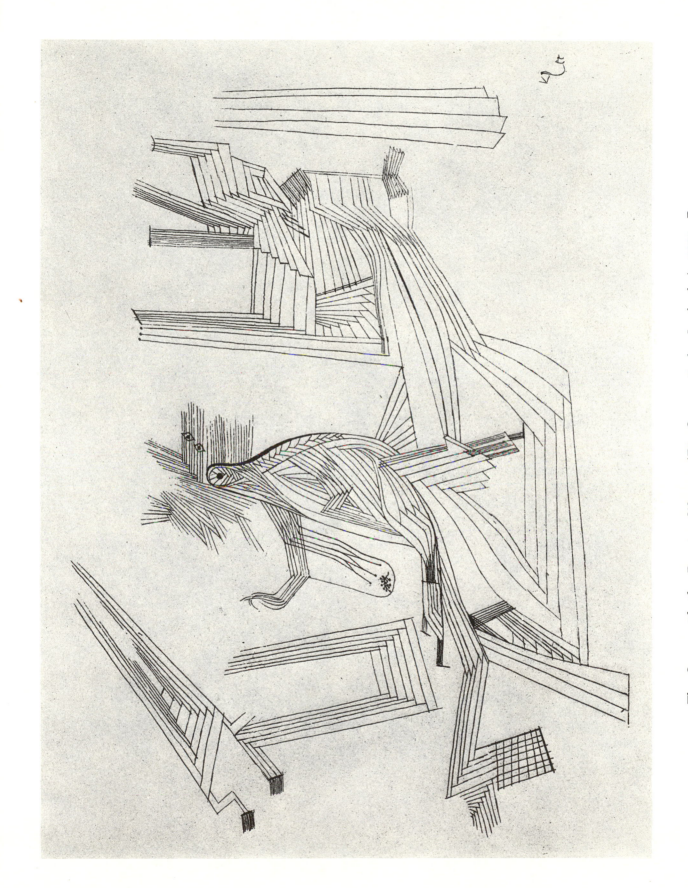

The Scene with the Running Woman (*Die Szene mit der Laufenden*). 1925. Pen. 8¼ x 11⅜ inches.

Dutch Cathedral (*Niederländische Kathedrale*). 1927. Pen. 12 x 18⅛ inches.

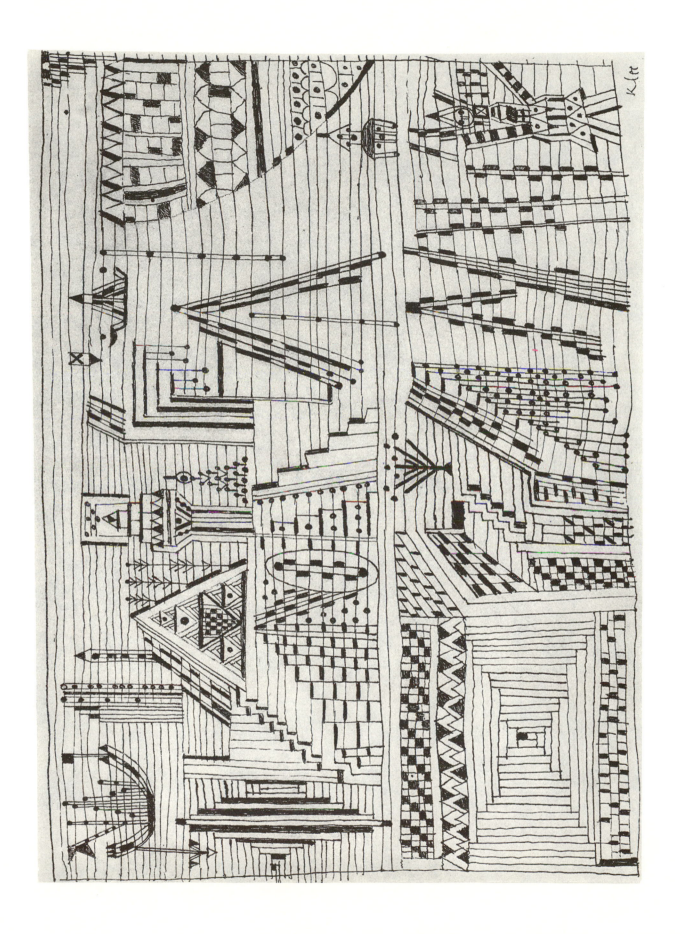

Beride, Town by the Sea (*Beride, Wasserstadt*). 1927. Pen. 6½ x 8¾ inches.

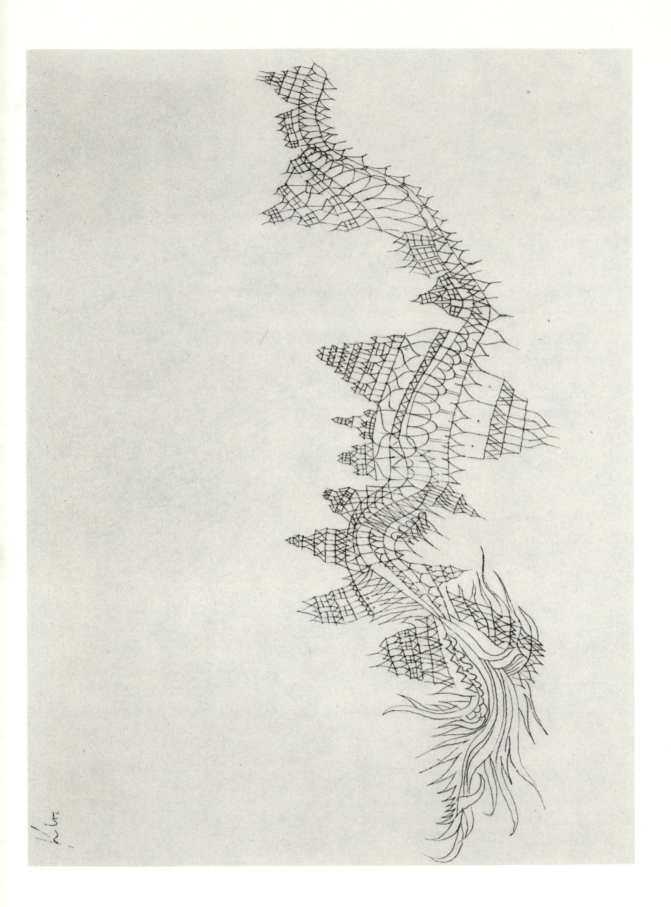

The Flood Washes Away Cities (*Die Flut schwemmt Städte*). 1927. Pen. 10½ x 12 inches.

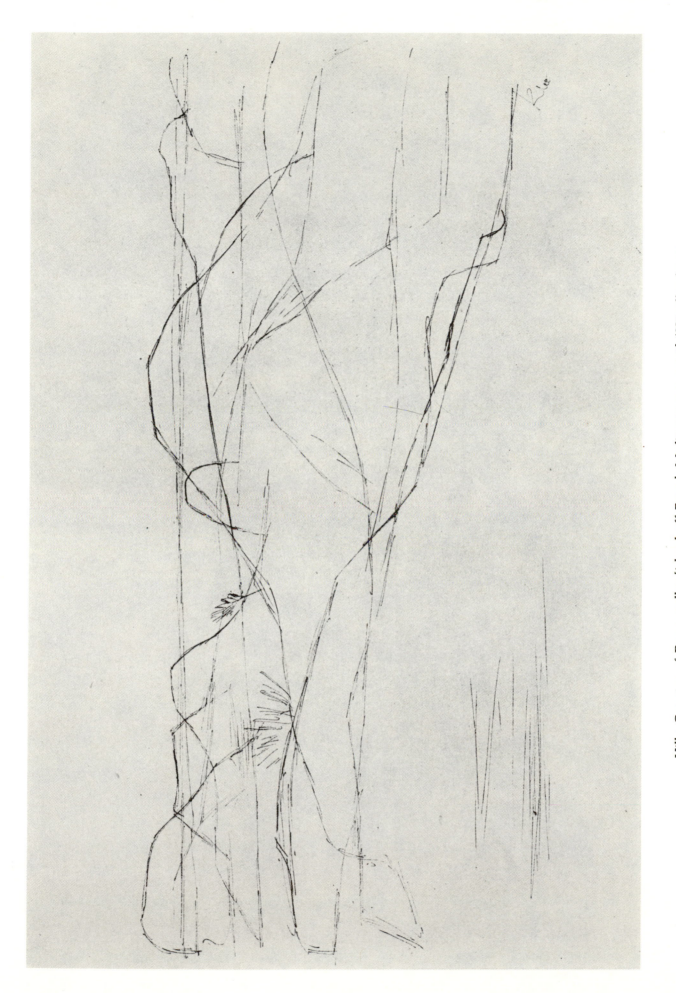

Hilly Country of Porquerolles [island off French Mediterranean coast] (*Hügelland von Porquerolles*). 1927. Pen. 11⅞ x 18⅛ inches.

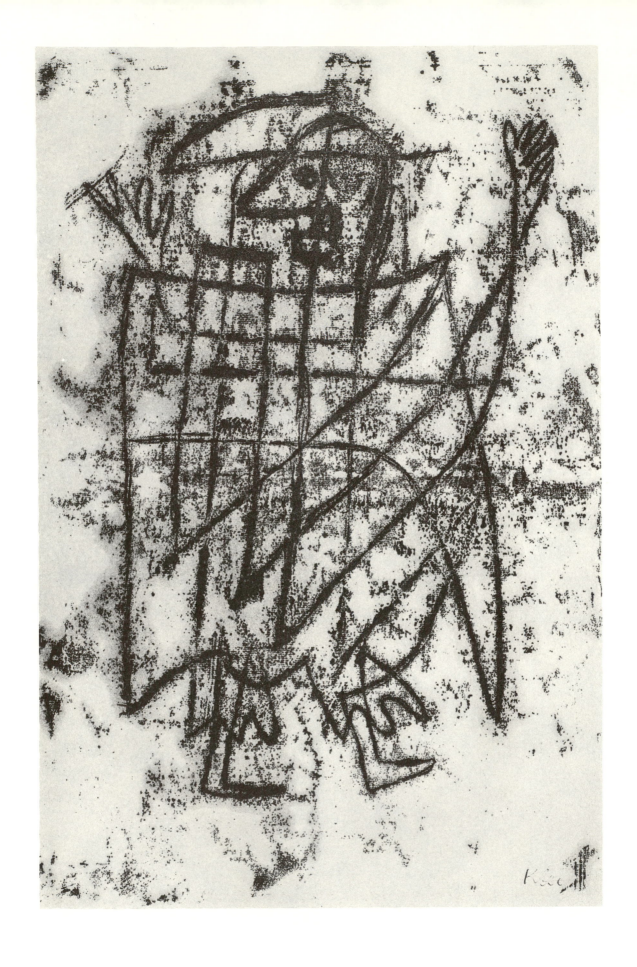

Costume Study for the Character Death (*Figurine "Der Tod"*). 1927. Crayon. 18⅛ x 11⅞ inches.

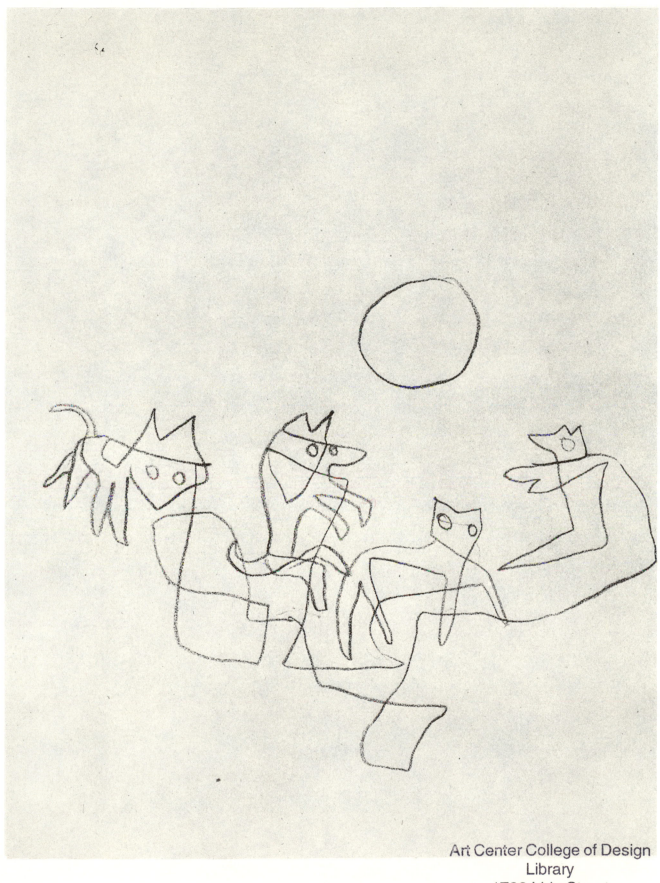

Animals at Full Moon (*Tiere bei Vollmond*). 1927. Chalk. 8⅞ x 6⅞ inches.

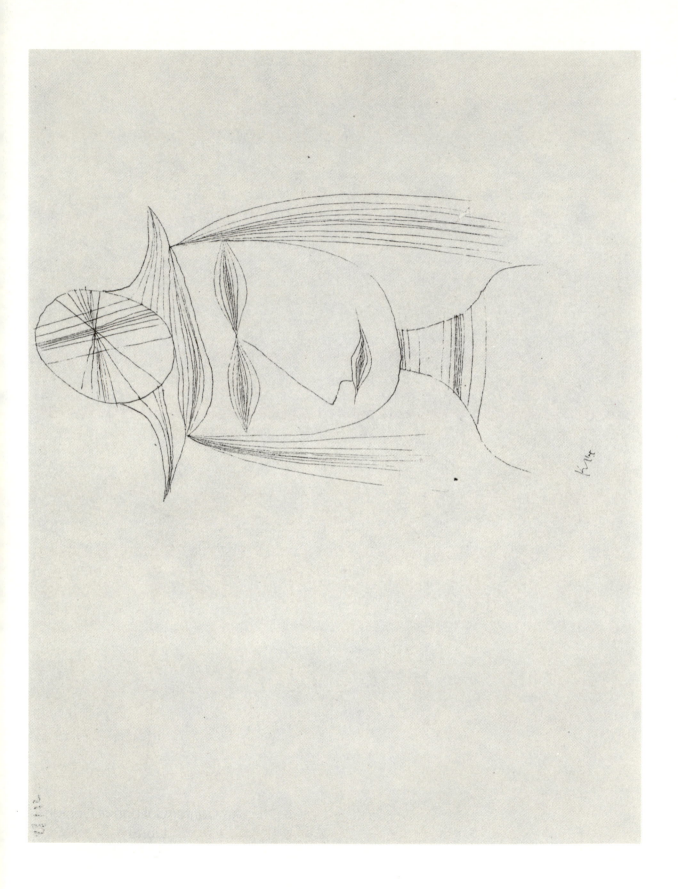

It's the Hat That Does It (*Der Hut macht's*). 1928. Pen. 9⅝ x 11⅞ inches.

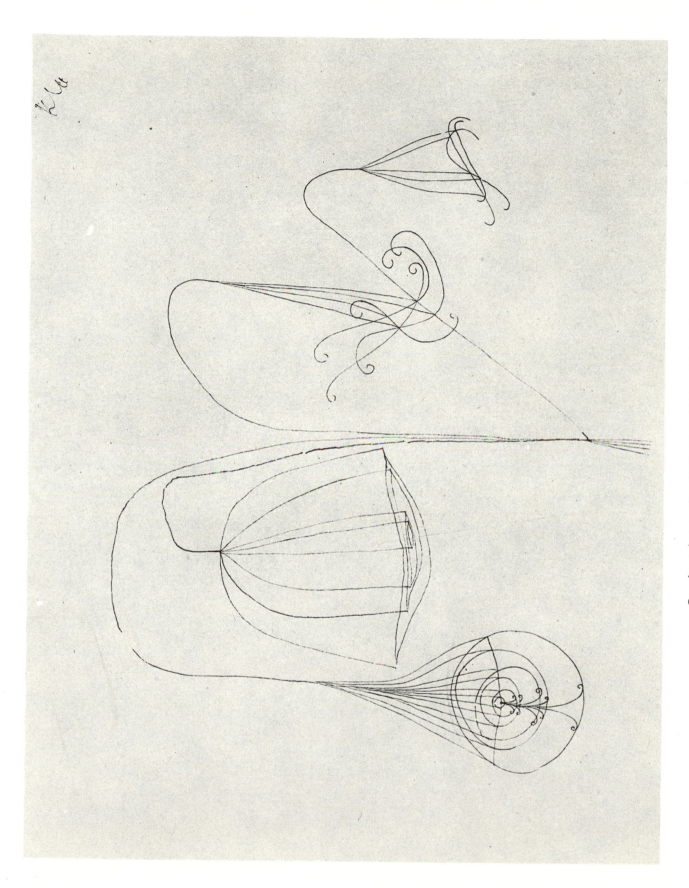

Quadrupula gracilis. 1927. Pen. 11¼ x 18¼ inches.

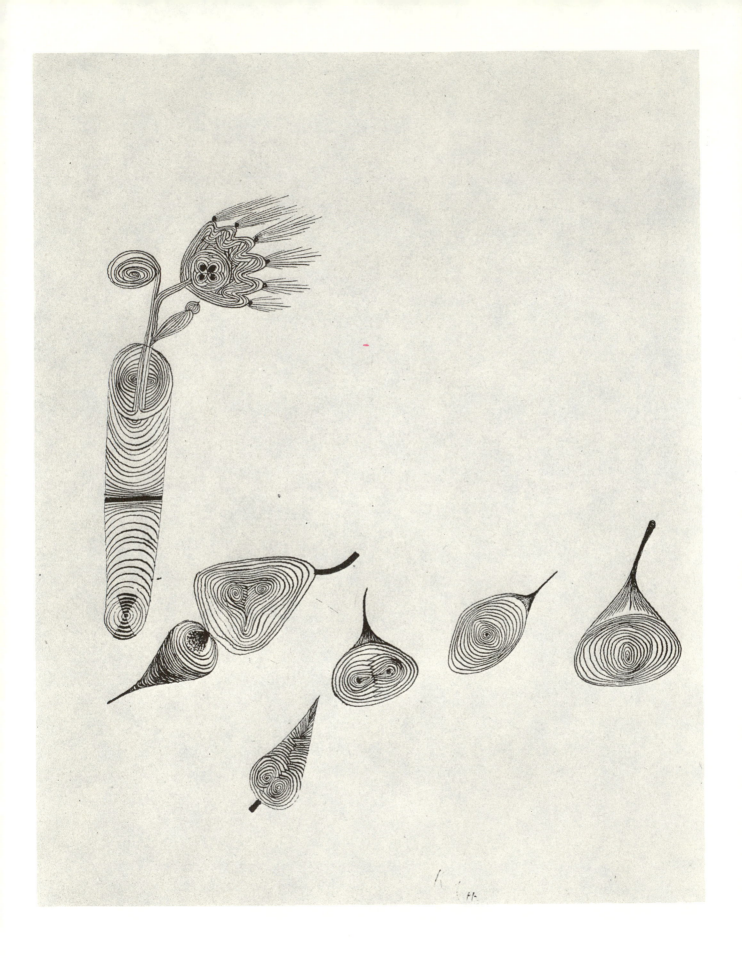

Flower and Fruits (*Blume und Früchte*). 1927. Pen. 14 x 11⅞ inches.

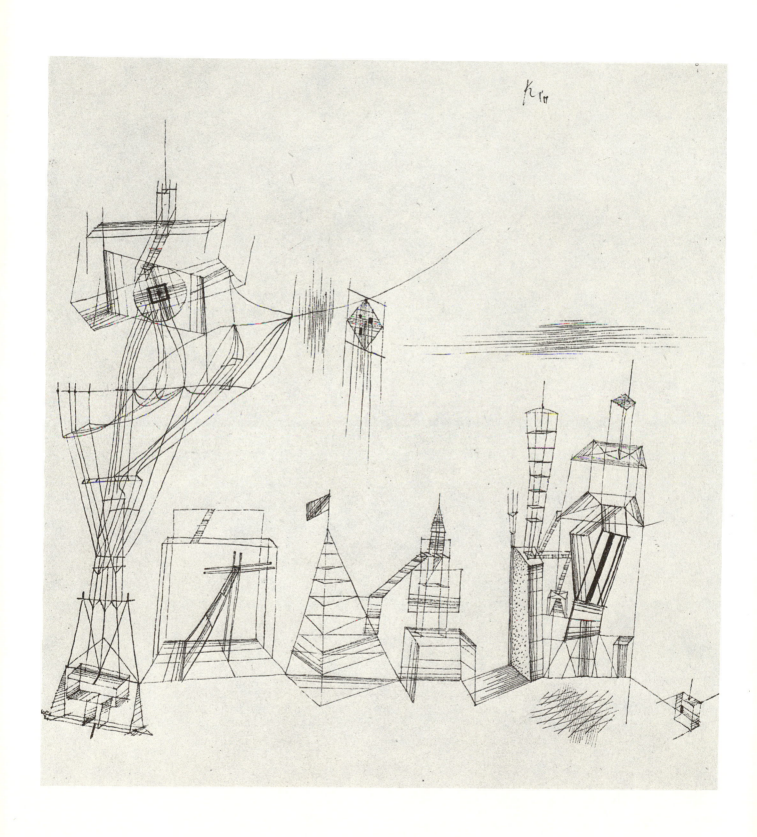

Stage Construction Site (*Bühnenbauplatz*). 1928. Pen. 12⅛ x 11¾ inches.

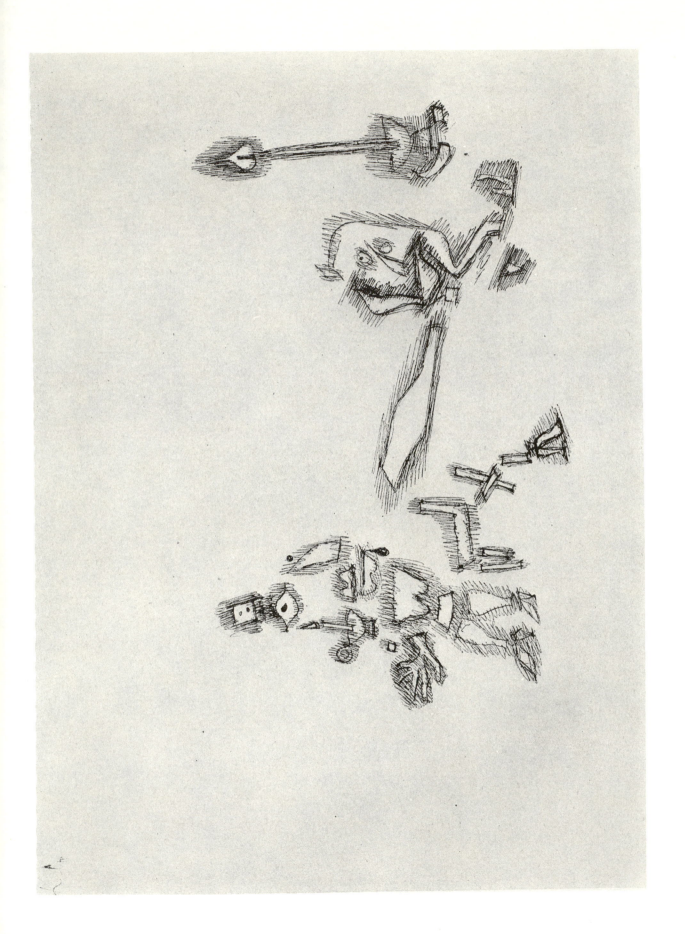

They Would Like to Be Obliged To (*Möchten sollen*). 1927. Pen. 11¾ x 17⅝ inches.

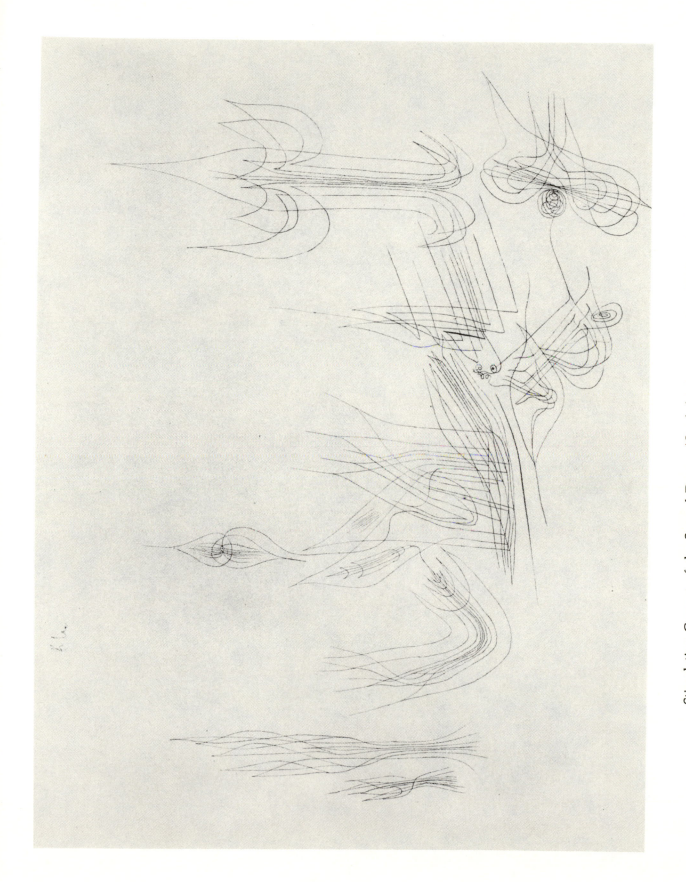

Stimulating Current of the Second Degree (*Stachelströmung zweiten Stadiums*). 1928.
Pen. 17⅞ x 23½ inches.

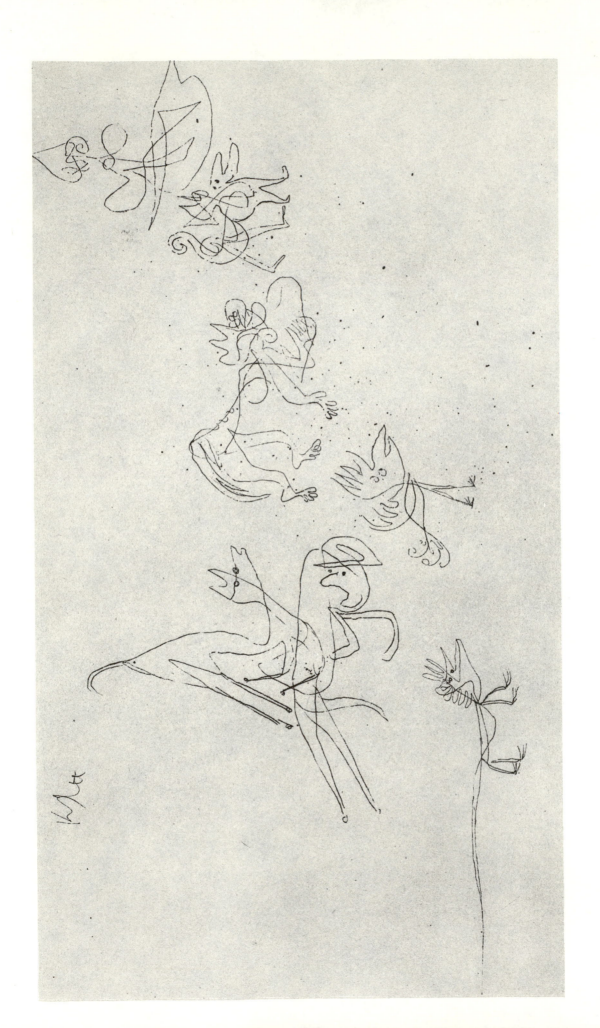

Animals on a Trek (*Tiere auf der Wanderung*). 1928. Pen. 9⅛ x 19⅛ inches.

She Is Leaving Us (*Sie verlässt uns*). 1928. Pen. 15¼ x 23⅜ inches.

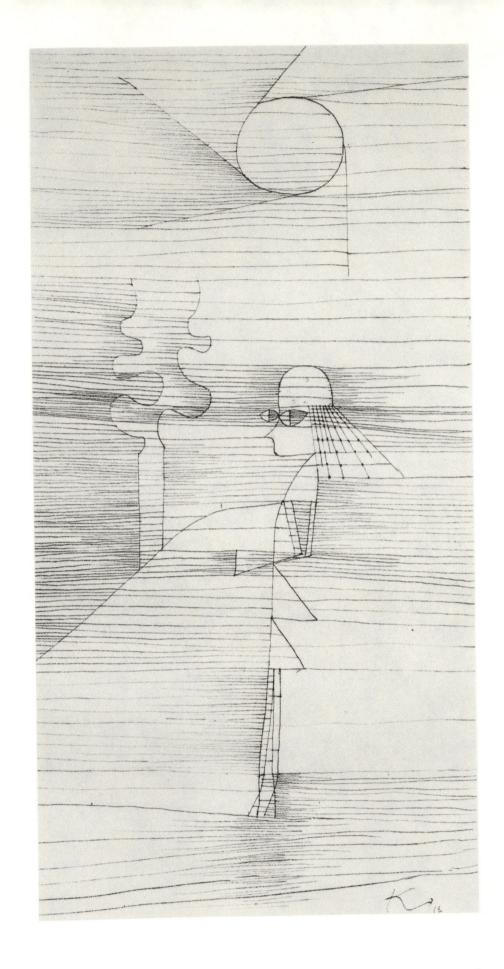

Girl Beneath the Sun (*Mädchen unter der Sonne*). 1929. Pen. 12⅝ x 6⅝ inches.

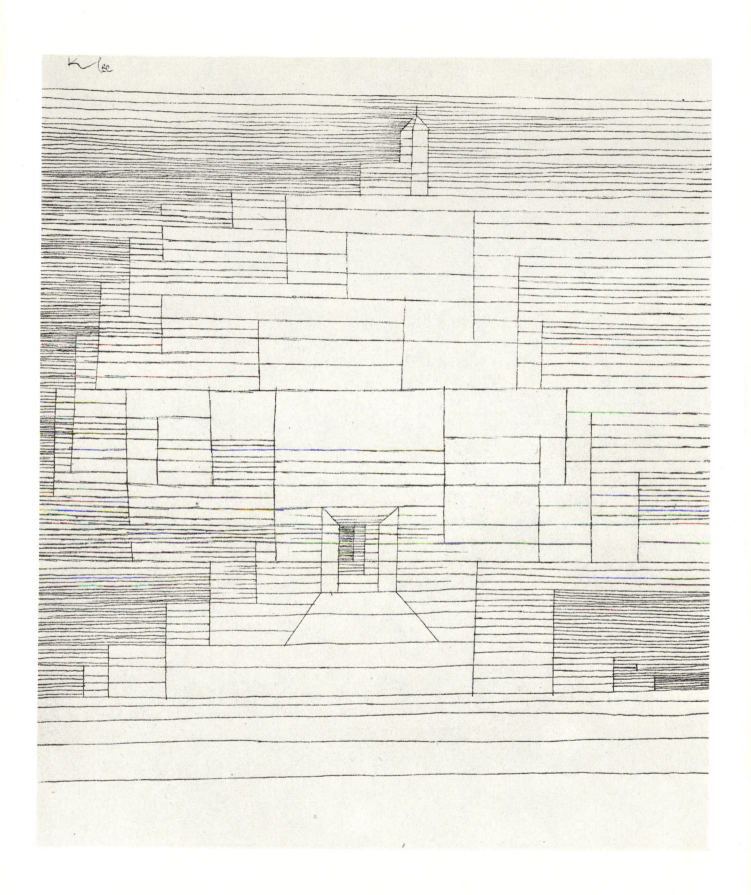

Castle of a Religious Order (*Ordensburg*). 1929. Pen. 11¼ x 9⅝ inches.

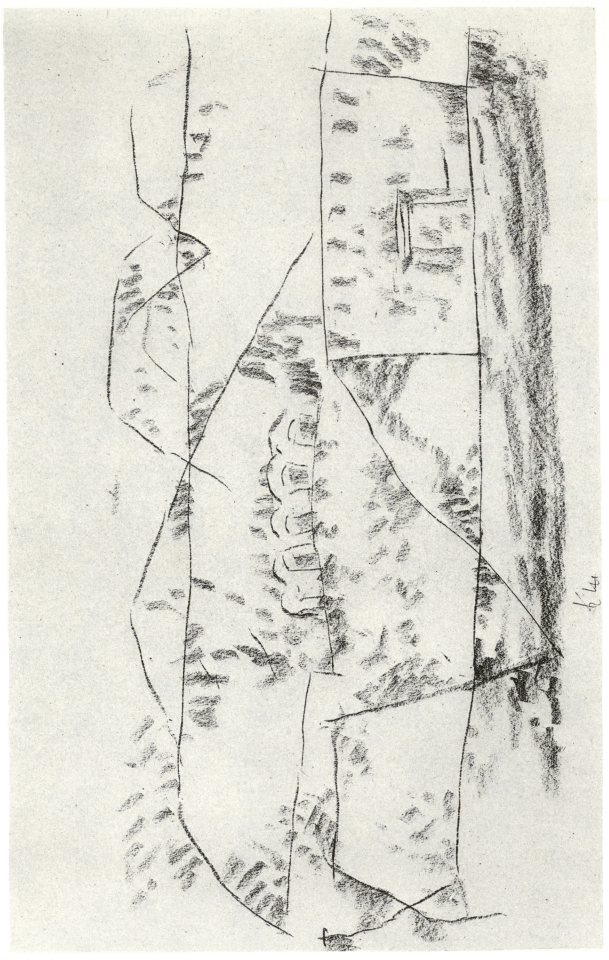

Rock Tombs (*Felsgräber*). 1929. Pencil. 8¼ x 12⅞ inches.

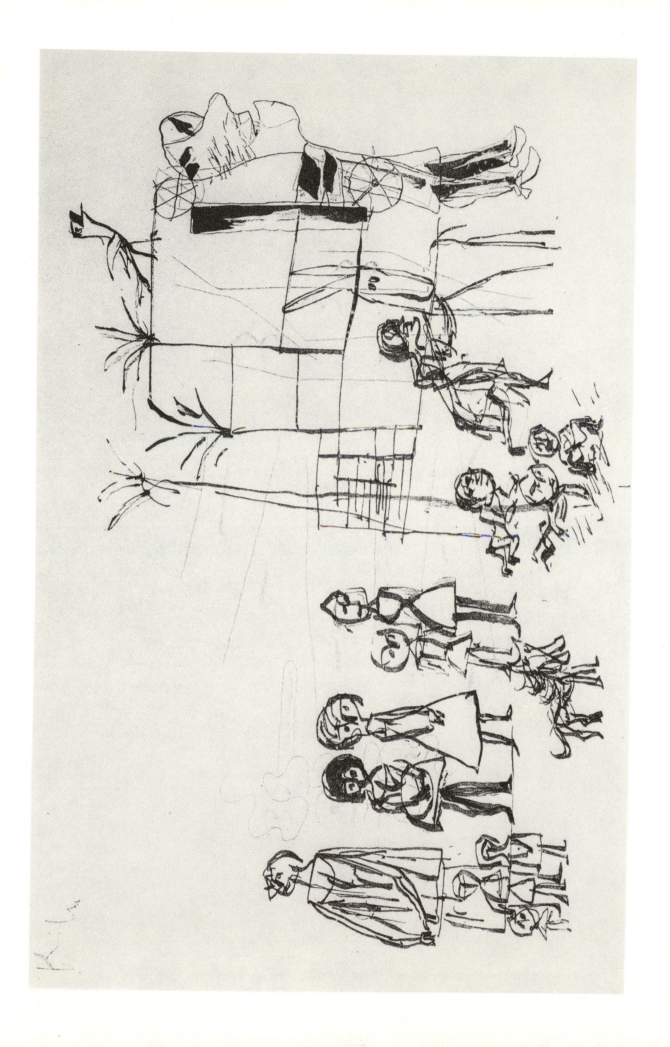

Inquisitive Children (*Neugierige Kinder*). 1929. Pen. 8¼ x 13 inches.

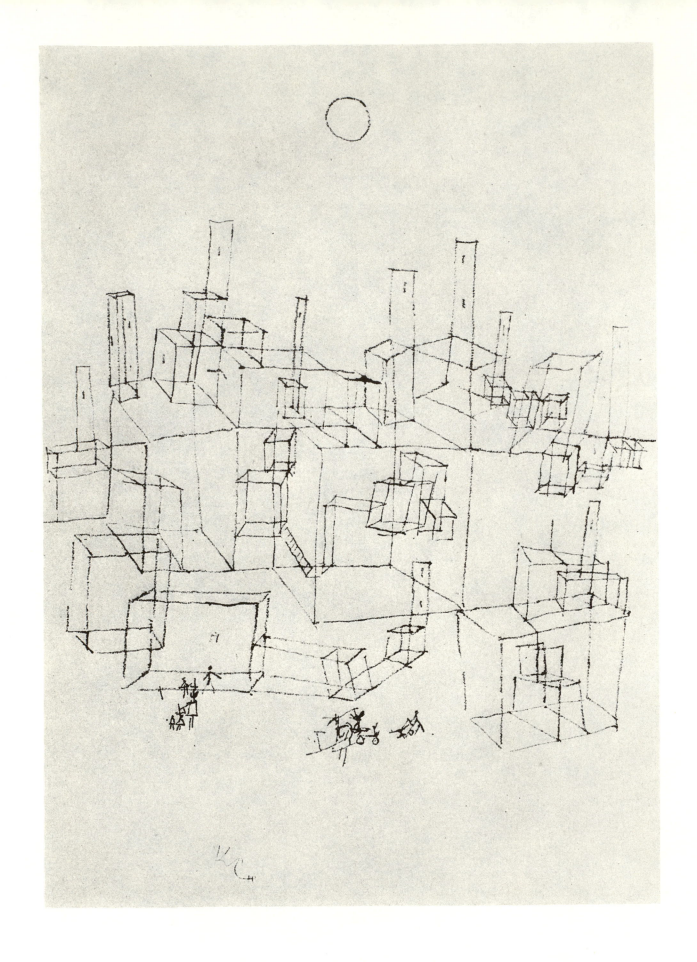

City with Watchtowers (*Stadt mit Wachttürmen*). 1929. Pen. 18 x 11¾ inches.

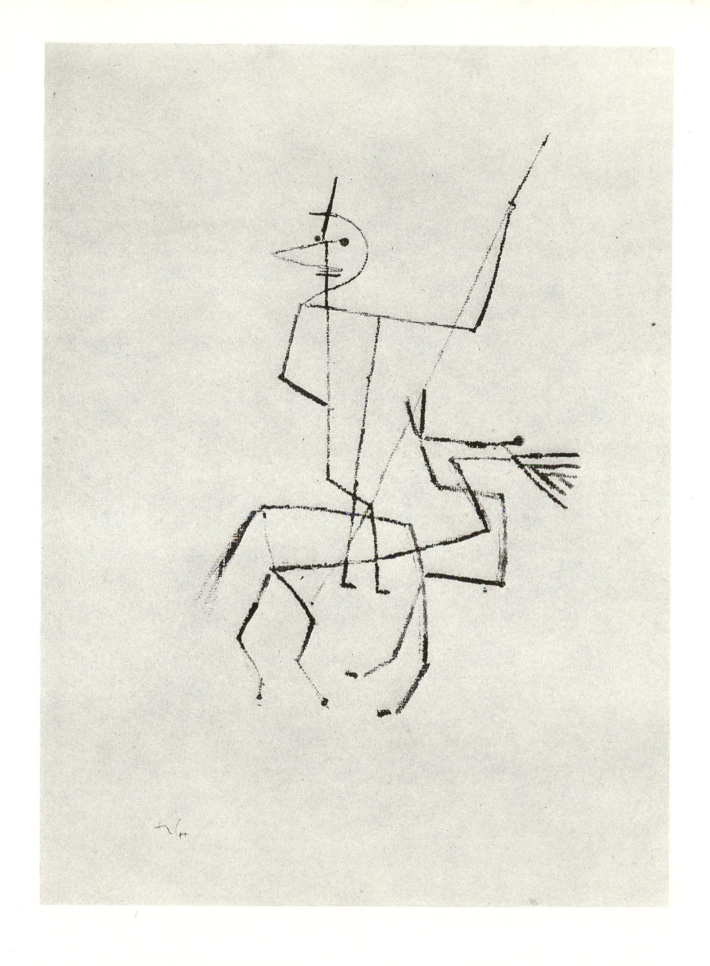

Horseman with Lance (*Reiter mit Lanze*). 1929. Pen. 17¾ x 11⅝ inches.

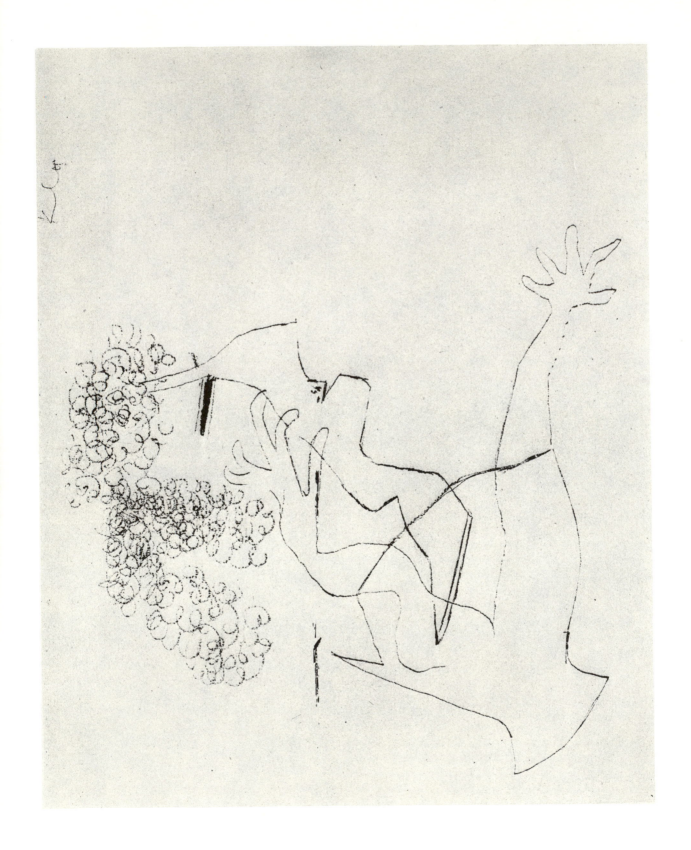

Head/Hands Divergence (*Divergenz Kopf-Hände*). 1929. Pen. 10 x 11¾ inches.

Creator II (*Schöpfer II*). 1930. Crayon. 14⅞ x 18½ inches.

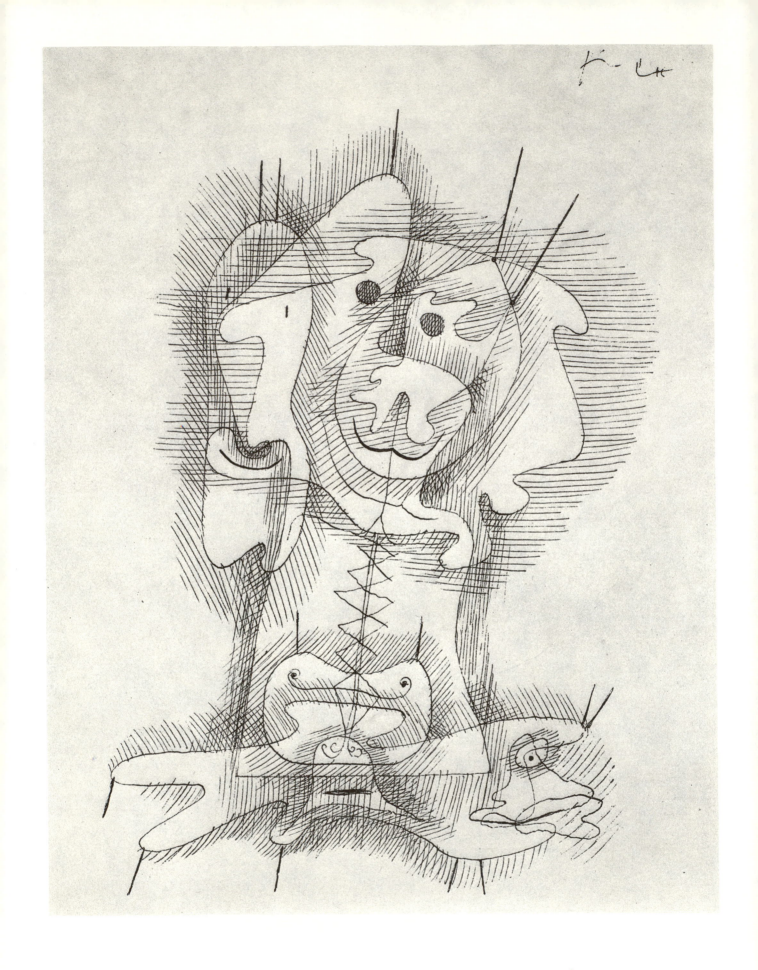

Composed Masks (*Komponierte Masken*). 1929. Pen. 8⅞ x 7¾ inches.

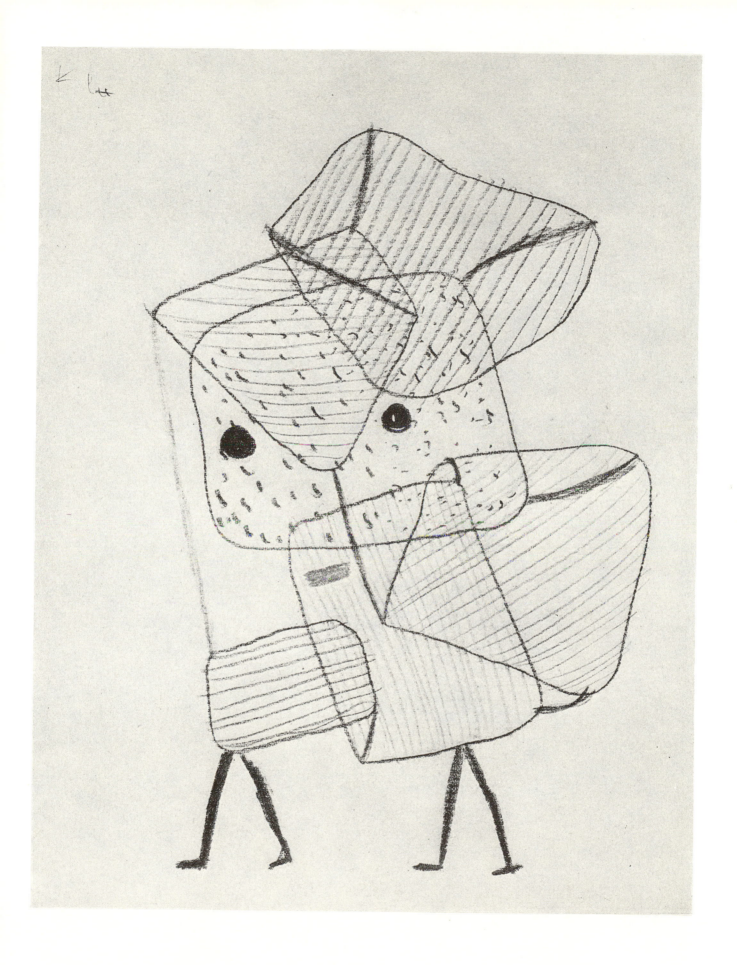

Children Carrying Packages (*Beladene Kinder*). 1930. Crayon. 11⅛ x 8⅝ inches.

Child, Large Version (*Kind, grosse Fassung*). 1930. Pen. 18⅞ x 23⅝ inches.

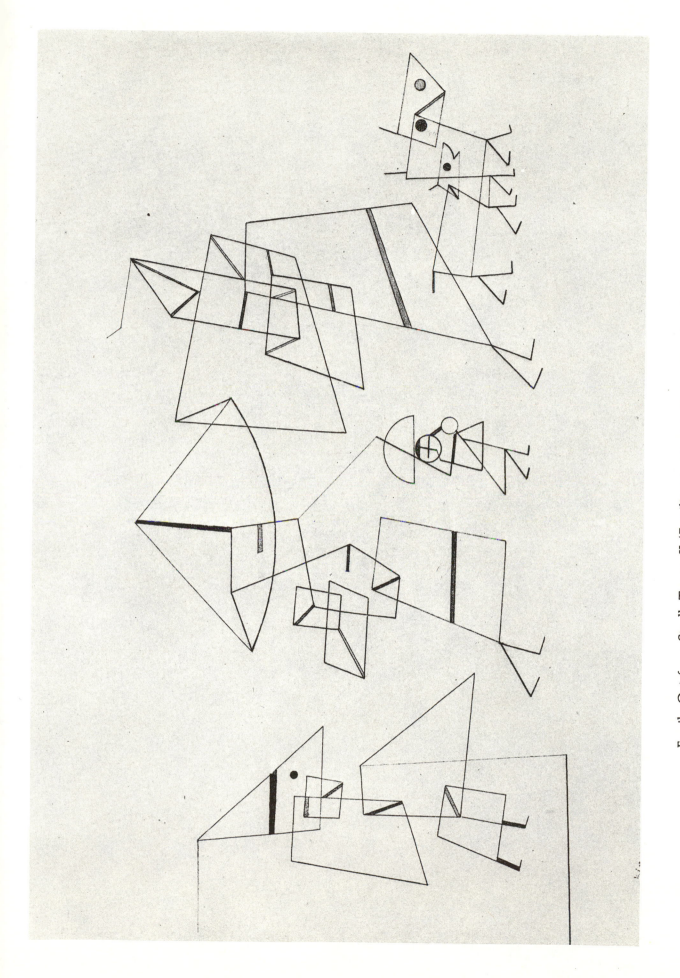

Family Out for a Stroll, Tempo II (*Familienspaziergang, Tempo II*). 1930. Pen. 15¾ x 22½ inches.

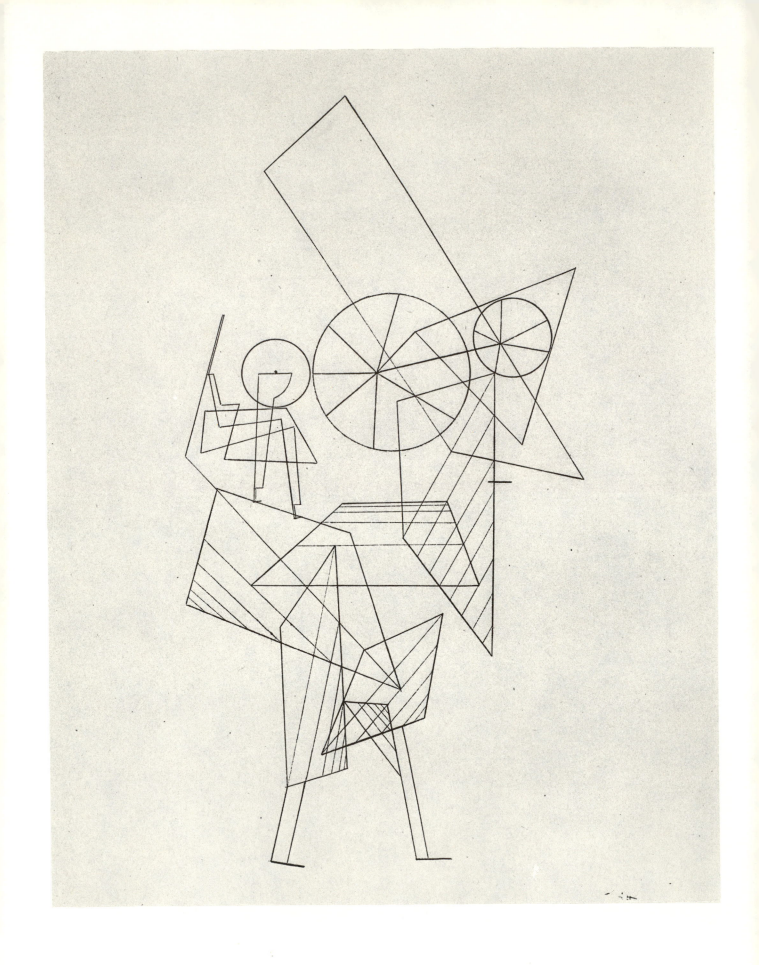

Docile-Dirigible Grandfather (*Lenkbarer Grossvater*). 1930. Pen. 23¼ x 18¼ inches.

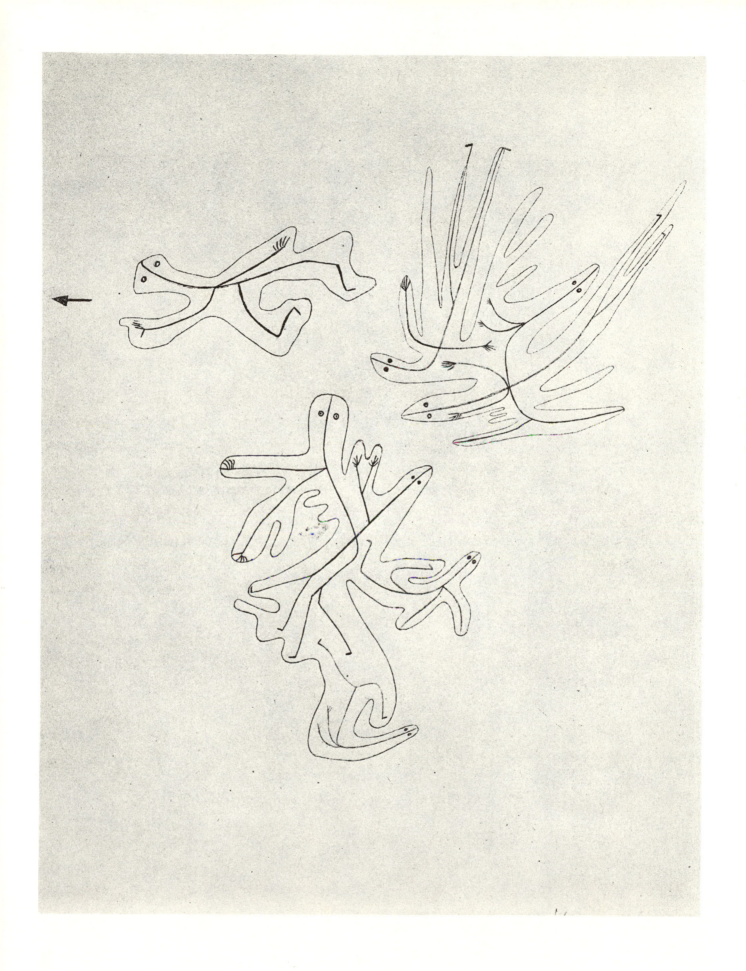

Spirits of the Air (*Luftgeister*). 1930. Pen. 18¾ x 14⅜ inches.

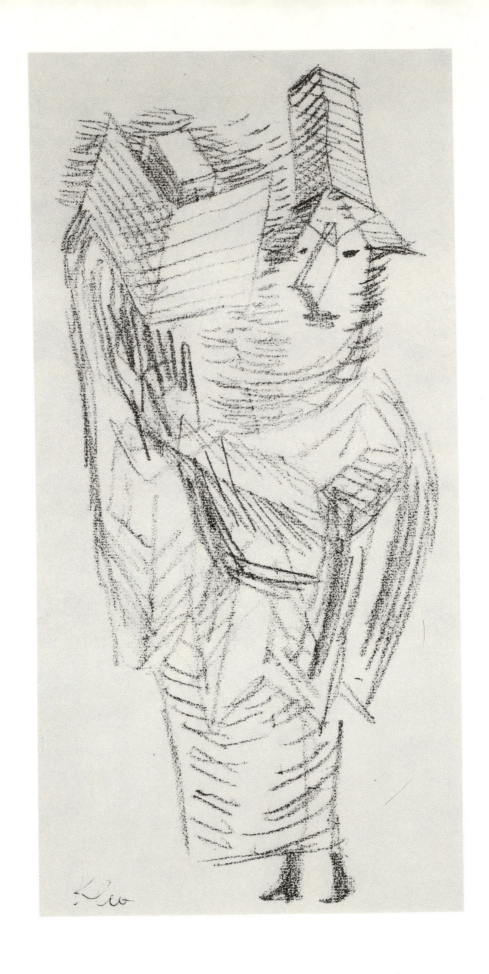

Pious Jew (*Frommer Jude*). 1930. Pencil. 13¾ x 6⅝ inches.

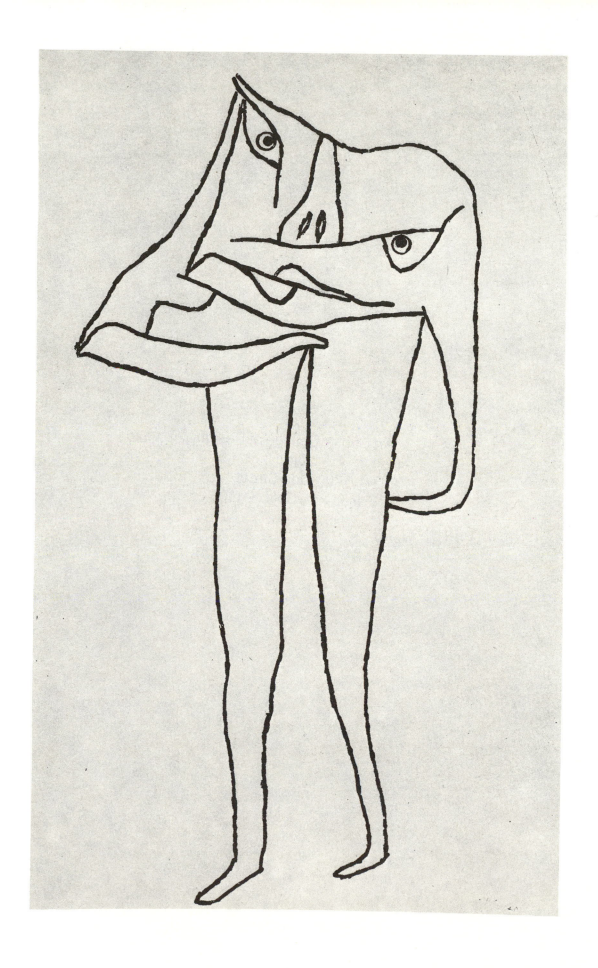

What's the Matter with Him? II (*Was fehlt ihm? II*). 1930. Crayon. 21¾ x 13⅜ inches.